In the Sunlight:
The Floral and Figurative Art
of J. H. Twachtman

In the Sunlight:
The Floral and Figurative Art
of J. H. Twachtman

Essays by Lisa N. Peters, William H. Gerdts,
John Douglass Hale, and Richard J. Boyle

A loan exhibition for the benefit of the
Archives of American Art,
Smithsonian Institution

10 May–10 June 1989

Spanierman Gallery

50 East 78th Street New York, New York 10021 (212) 879-7085

Published in the United States of America
in 1989 by Spanierman Gallery,
50 East 78th Street, New York, N.Y. 10021

© 1989 Spanierman Gallery

ISBN 0-945936-03-6

Contents

Introduction

In the Sunlight is our second exhibition to focus on a particular aspect of John Henry Twachtman's work. The first, *Twachtman in Gloucester: His Last Years, 1900–1902,* held in May–June 1987, revealed the boldness and modernity of the final paintings the artist created during summers spent in Gloucester, Massachusetts, and made us aware not only of his wonderful late paintings, but also of a great promise cut short by an untimely death.

In the Sunlight looks closely at two subjects depicted by Twachtman during his Greenwich years: flowers and figures. These rare subjects, rendered roughly from 1889, when he moved to Greenwich, Connecticut, until his death in 1902, have never previously been considered in an intensive study. Thus, this exhibition has provided the opportunity to fill a gap in Twachtman scholarship and has allowed us to date and catalogue an important group of works that will be included in our forthcoming Twachtman catalogue raisonné.

The four essays in this catalogue are interrelated, yet present different points of view on Twachtman's floral and figurative works. Lisa N. Peters discusses Twachtman's actual garden in Greenwich and the relationship of his works to their sites. William H. Gerdts explores the chronology of Twachtman's pastels and paintings of flowers and examines their unique position among American floral depictions. John Douglass Hale considers Twachtman's renderings of the figure and how they differ from established figural conventions. Richard J. Boyle investigates the floral works as a key to an understanding of Twachtman's technical procedures and his mastery of method.

As these essays reveal, Twachtman's work continues to compel our attention for its beauty, poetry, and strength. We are especially struck by these qualities in the artist's floral and figurative renderings, and we are pleased to share this experience of these works with the public.

I would like to thank Lisa Peters, who curated this exhibition, and our catalogue authors, Richard J. Boyle, William H. Gerdts, and John Douglass Hale, as well as the many members of our staff who participated, notably, David Henry, Jean Carlson, Carol Lowrey, Laurene Buckley, Ellery Kurtz, Suzanne Meadow, Estelle Yanco, and Judy Salerno.

Ira Spanierman

fig. 1
John Henry Twachtman, *Wild Flowers,*
ca. 1889–1891. Pastel on paper, 19 × 11½ in.
(48.3 × 29.2 cm.). National Museum of
American Art, Smithsonian Institution,
Washington, D.C., Gift of John Gellatly.

Acknowledgments

This catalogue, and the exhibition it accompanies, attest to Ira Spanierman's continued support for and interest in the works of John Henry Twachtman. His encouragement and involvement in this undertaking have been of immeasurable value and have provided inspiration at every step of the way. We are now in our third year of compiling a catalogue raisonné of Twachtman's works. Thus this exhibition is of particular significance as it provides a point of reference within the larger framework of our ongoing research.

Investigating Twachtman's floral and figurative imagery has indeed been a pleasure for all involved, and I especially want to thank our catalogue authors, Richard J. Boyle, William H. Gerdts, and John Douglass Hale, for their important and thoughtful contributions to Twachtman scholarship.

Many members of the Spanierman Gallery provided essential assistance to this effort. David Henry gave vital consultation on every aspect of the project. For her aid in all phases of research, editing, and coordination, I am extremely grateful to Jean Carlson. As bibliographic editor, Carol Lowrey provided a crucial contribution to the catalogue and, together with Laurene Buckley offered helpful suggestions on my essay and catalogue entries. I am indebted to Ellery Kurtz, Registrar, who arranged the shipping and installation of works. Help and support were also furnished by Gregg Deering, Michael Horvath, Betty Krulik, Suzanne Meadow, Mary Nowak, Kevin Phillips, Judy Salerno, Traian Steanescu, and Estelle Yanco.

Others gave valuable assistance to this endeavor. Sheila Schwartz did a superb job of editing the catalogue. David Dearinger and Lisa Chaliff added tremendously to our research files on Twachtman through diligent and careful pursuit of contemporaneous newspaper articles. Kathryn Wilmerding and Jennifer Firestone also supplied research help. Cheryl Liebold located relevant material in the Archives of the Pennsylvania Academy of the Fine Arts. Patricia Twachtman, Sally Twachtman, and Eric Twachtman shared recollections of the artist's home and made available to me the important photograph of the Twachtman house from the early 1890s. For providing images of works reproduced in this catalogue, I wish to thank Anna Ely Smith and Lyn Ely, among others, as well as the staffs of the following institutions: Museum of Fine Arts, Brigham Young University, Provo, Utah; Cincinnati Art Museum; The

Fine Arts Museums of San Francisco; Freer Gallery of Art, Smithsonian Institution, Washington, D.C.; Galleries of the Claremont Colleges, California; Historical Society of the Town of Greenwich, Cos Cob, Connecticut; Kennedy Galleries, New York; Meredith Long & Company, Houston; Munson-Williams-Proctor Institute, Utica, New York; Museum of Art, Rhode Island School of Design, Providence; Museum of Fine Arts, Boston; Museum of Fine Arts, Springfield, Massachusetts; National Gallery of Art, Washington, D.C.; National Museum of American Art, Smithsonian Institution, Washington, D.C.; The Nelson-Atkins Museum of Art, Kansas City, Missouri; North Carolina Museum of Art, Raleigh; Vose Galleries, Boston; and Whitney Museum of American Art, New York.

For their assistance in retrieving reference material, I am grateful to the staffs of a number of institutions: Archives of American Art, New York; Brooklyn Botanic Garden Library, New York; Frick Art Reference Library, New York; Harold B. Lee Library, Brigham Young University, Provo, Utah; Thomas J. Watson Library, The Metropolitan Museum of Art, New York; National Museum of American Art/National Portrait Gallery Library, Washington, D.C.; The New York Public Library; New York Society Library; Princeton University Library, New Jersey; and Whitney Museum of American Art Library, New York.

My deepest gratitude, however, is extended to those who lent works to the exhibition. I am truly indebted to our private lenders, Mr. and Mrs. Raymond J. Horowitz, Ira and Nancy Koger, Mr. and Mrs. Meyer P. Potamkin, Erving and Joyce Wolf, and anonymous lenders, all of whom cooperated enthusiastically on this project and generously parted with their works. Many members of museum staffs offered support and helped to facilitate loans, notably Robert Buck, Linda Ferber, Barbara Dayer Gallati, and Marguerite Lavin, The Brooklyn Museum, New York; Richard Schneiderman, John Coffey, Peggy Jo Kirby, and Carrie Hastings Hedrick, North Carolina Museum of Art, Raleigh; Ellen Schall, Maier Museum of Art, Randolph-Macon Woman's College, Lynchburg, Virginia; Linda Bantel, Susan Danly, and Robert Harman, Pennsylvania Academy of the Fine Arts, Philadelphia; and Elizabeth Broun, Joann Moser, Margaret Harman, and Lenore Fein, National Museum of American Art, Washington, D.C.

Lisa N. Peters

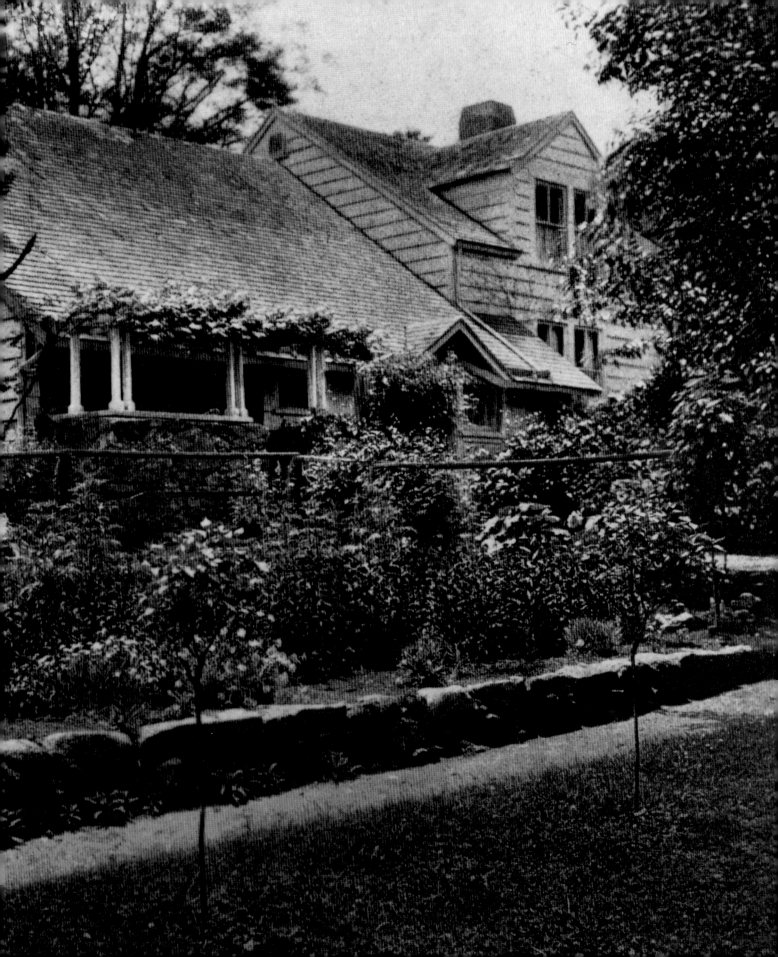

Twachtman's Greenwich Garden

by Lisa N. Peters

In 1889, John Henry Twachtman settled with his wife and children in Greenwich, Connecticut, purchasing a house and seventeen acres of land that furnished the subject matter for his works for the rest of his career.[1] From that date until his death in 1902, he focused his attention on painting the back and front of his house, the brook that ran through his property, the pool and waterfall that extended off the brook, and his garden. Twachtman's paintings of his garden are among his most sensual and vibrant, and a study of them provides an understanding of his ability to express essential and vital qualities in nature.

We can, however, only conjecture as to the actual appearance and contents of Twachtman's Greenwich garden. Unlike the garden of French Impressionist Claude Monet, for which there are numerous photographs and papers documenting its changes throughout the artist's tenure in Giverny, we have no contemporaneous sources—photographic or archival—that provide information about Twachtman's garden. This is not an unusual problem in Twachtman research. The artist left behind only scant records of his artistic production and of his personal life. There are few letters from the Greenwich years, no journals or other papers that would explain the changes on his property, such as the many additions made to his house throughout the decade. These were also years in which Twachtman left his works undated, so that the works themselves do not offer definitive evidence of how the garden was arranged.

It is, however, fortunate that Twachtman's house in Greenwich remains to a large extent as it was during his last years there, which enables us to determine at least the plot of the garden. Situated behind the house, it extended about 100 feet and ended at the entrance to a small barn, which stood against the base of a steep hill. A photograph taken in the early 1890s and hitherto unpublished shows the house before the additions and the square-shaped barn behind it that was the boundary line of the garden (fig. 3).[2] The relationship between house and barn can also be seen in another photograph that captures the right corner of the front porch (which had been converted by the mid-1890s to an open-air dining room covered by an overhead trellis) and the barn, visible in the background through the trees (fig. 4). This association has been maintained, although the barn was later reconstructed and a dormer window added to it (fig. 5). As these photographs show, both structures were built at the edge of Round Hill Road, then quiet and clear of traffic. The road appears in a number of works, among them Twachtman's well-known painting of it in the National Museum of American Art (fig. 6). He also included the road in many paintings

fig. 2
Back of Twachtman's house on Round Hill Road, Greenwich, ca. 1902–1905. Photograph. From Goodwin, "An Artist's Unspoiled Country Home," p. 630. Courtesy of The New York Public Library.

of the back of the house looking toward the barn in winter. In these, thick snow cover blurs the boundaries of road, the backyard (where the garden grew in the summer), and the barn (fig. 7). The road is, however, always omitted in paintings of the garden. Whether seen in close up as in *Tiger Lilies* (fig. 8) or from a more distant vantage point as in *The Cabbage Patch* (pl. 4), the garden always appears sealed off and remote from the outside world.

Despite its isolation, the garden is often inextricably linked with the back of Twachtman's dwelling, providing a transition between the ruggedness of nature and the calming domestic sphere of the home. Standing between house and barn, it provided a semicultivated passageway that both connected the buildings visually and allowed release from their confines. Twachtman explores many different relationships between house and garden. Each changes the appearance of the other, as if a particular view of one generated a new look at the other. This approach answered his constant search for new ways of seeing. A photograph included in Alfred Henry Goodwin's important 1905 article on Twachtman's Greenwich property shows the back of the house, a section of the garden immediately beneath it, and the covered porch supported by double columns and covered with a vine trellis (fig. 2).³ This part of the residence appears from different vantage points in a number of Twachtman's garden paintings, including *The Cabbage Patch, A Garden Path* (pl. 7), and *On the Terrace* (pl. 11). The small gable over the door, featured in all these works, seems to have been a favorite motif, its crisp outline creating a focal point and a means of capping the jumble of flowers that rise up toward it. In *On the Terrace*, the gable also crowns the figures of his wife and daughters, linking them to the house and the beauty of the floral environment. Twachtman alters the gable and other architectural elements, depending on whether they are seen in winter or in summer. In views of the back of the house in winter, the gable is discernable only as a slight shift in the outline of the house's facade; in the garden paintings, it takes on a more significant role. Due to its small size, it seems to comply with the scale of the flowers in a way that a large roof gable could not. In winter scenes, the back of the house is considered as a large collage of shapes; in the

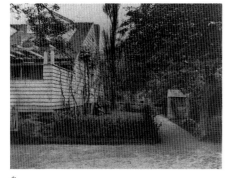

garden paintings, Twachtman delights in the more intricate patterns of the double column supports, the overhead trellis with vines and the human scale of the gabled doorway, flanked by potted plants.

The barn is also one of Twachtman's most frequently painted motifs. It is rendered in numerous winter scenes, often depicted as if isolated in the midst of a snow-filled meadow and viewed from a great distance. In these works, it appears to be overwhelmed by the surrounding landscape (fig. 9). In garden paintings, on the other hand, it appears larger and closer to the viewer. Shown with clearly stated contours, it assumes a solid strength and monumentality that contrasts with the flickering movement and lightness of the flowers. In *Azaleas* (pl. 6), the large, blocky and imposing structure echoes the orderly arrangement of the painting. In the painting titled *In the Greenhouse* (pl. 5), the roof of the barn anchors the composition and restrains the upward-floating blossoms.

Twachtman's garden seems to have contained primarily flowers. Goodwin wrote that the house "is one of the few blessed country places where nothing is done of a useful rural sort. There are no swarms of poultry to defile the morning air. No attempt is made to supply the table from out of the back yard."[4] However, as the broad-leafed plants in the foreground of Twachtman's *The Cabbage Patch* suggest, there may indeed have been vegetables in the garden. The rows of plantings and the fence in the left background also provide evidence that plants other than flowers were grown. Twachtman captured this scene from the top of the hill above the barn in order to encompass both the wide angle on the burgeoning foliage and the lines of the roof and back porch beyond. This same viewpoint may be seen today, although it is somewhat obscured by thick foliage (fig. 10).

The best record of the garden is provided by the paintings themselves. Yet, despite the different views that include the house and barn, they do not present a cohesive view of the garden; they cannot be "completed," as if they were parts of a puzzle. In some images, such as *Azaleas* and *A Garden Path* (pls. 6, 7), the

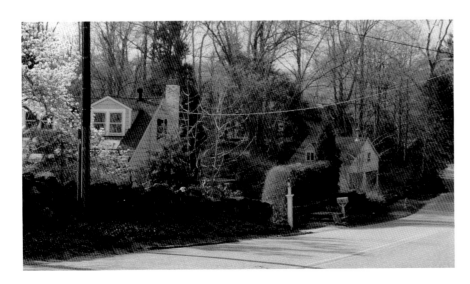

fig. 5
Twachtman's house and barn (reconstructed) along Round Hill Road, Greenwich, 1988. Photograph taken by the author.

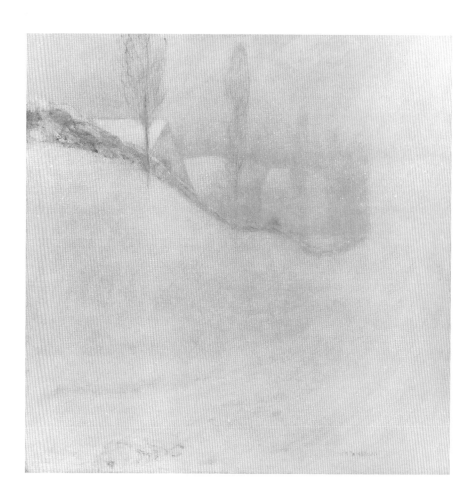

fig. 6
John Henry Twachtman, *Round Hill Road,*
ca. 1890-1900. Oil on canvas, 30¼ × 30 in.
(76.8 × 76.2 cm.). National Museum of
American Art, Smithsonian Institution,
Washington, D.C., Gift of William T. Evans.

garden appears to be quite orderly, whereas in *The Cabbage Patch* it spreads in all directions, almost consuming the house. Other works, such as *In the Greenhouse*, suggest that the garden was untended, with densely planted flowers crowding each other for space. In greater contrast to the carefully tended rows of *Azaleas* are the unconstrained flowers depicted in *Tiger Lilies* (pl. 3), *The Flower Garden* (fig. 11), and *Wildflowers* (pl. 2), which appear to be set in nature rather than within a garden plot.

It may be, in fact, that the variety in the paintings reflects a progression that occurred in the garden over the course of the Greenwich years. As we know from exhibition listings and reviews, the first floral images that Twachtman exhibited during his Greenwich years were pastels. The following essay in this catalogue by William H. Gerdts discusses these in the context of the exhibitions of Twachtman's early Greenwich years. Since most of the pastels present weeds and wildflowers that would not have been nurtured in the garden, they were undoubtedly inspired by the plants of the field either on Twachtman's property or in the Greenwich countryside (or possibly near Branchville, Connecticut, where Twachtman spent time in the late 1880s with his friend J. Alden Weir). Weeds and wildflowers could also have been growing in Twachtman's backyard before a garden was planted there. His interest in wild blooms also emerges in

the paintings he exhibited during his early Greenwich years. *Meadow Flowers* (pl. 1), in particular, resembles Twachtman's pastel imagery in the depiction of blossoms against a soft neutral background, and its title indeed suggests that its floral clusters were those of the countryside rather than those of the tended plot. Other paintings of flowers growing freely in the landscape, *The Flower Garden* (fig. 11), *Wildflowers* (pl. 2), and *Tiger Lilies* (pl. 3), also convey the artist's interest in wilder aspects of nature. These paintings, like *Meadow Flowers*, could present the floral embellishment of the fields, but they also could depict the garden. Indeed, since the phlox flowers that are featured in *The Flower Garden* and in *Wildflowers* resemble those shown in two other paintings definitely set in the garden, *In the Sunlight* (pl. 9) and *On the Terrace* (pl. 11), it is likely that the garden is the location for all. Twachtman's garden also included tiger lilies, which may be seen in the background of *The Cabbage Patch* (pl. 4); thus *Tiger Lilies* (pl. 3) also might have been rendered just beyond the back doorstep of the artist's residence.

As Gerdts's essay further suggests, *Meadow Flowers* and *Tiger Lilies* (pl. 3) could have been two of the works included in the May 1893 exhibition at the American Art Galleries that Twachtman shared with Weir. Thus Twachtman was probably interested in wilder blooms during his early Greenwich years in particular, and his tending of his garden may have paralleled this concern. However, over the course of the years, it seems likely that he cultivated his garden, cutting back overgrown plantings to carve the clear paths, shown in *Azaleas* (pl. 6) and in *A Garden Path* (pl. 7), and the open area depicted in *On the Terrace* (pl. 11), a work displayed in the first exhibition of the Ten American

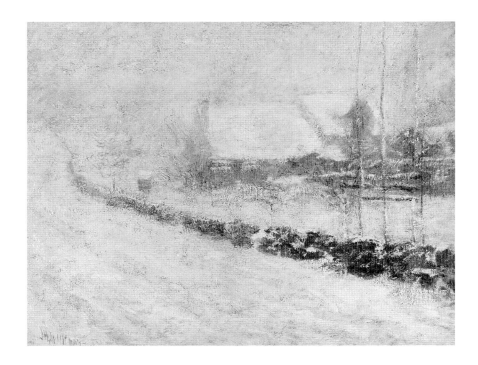

fig. 7
John Henry Twachtman, *Snowbound*, ca. early 1890s. Oil on canvas, 22 × 30⅛ in. (55.9 × 76.5 cm.). Scripps College, Claremont, California, Gift of General and Mrs. Edward Clinton Young, 1946.

fig. 8
John Henry Twachtman, *Tiger Lilies*,
ca. late 1890s. Oil on canvas, 30⅛ × 25 in.
(76.8 × 63.5 cm.). Private Collection.

Painters in 1898. However, even in these paintings, the freedom of the flowers and their natural growth in the landscape is evident. While there may have been a general progression in Twachtman's garden toward a greater formal order, he did not exert an overwhelming amount of control, allowing flowers to flourish with a certain degree of naturalness.

In fact, the main flower featured in many of the garden paintings can be identified as the phlox, which is more common to natural and wild, rather than to cultivated, gardens due to its tendency to overflow the boundaries of plot and yard. The original title of *The Flower Garden* was *Pink Phlox*, and other works titled *Phlox* are listed in exhibition catalogues of Twachtman's works. He may have chosen the phlox for the garden because it can thrive without much attention and, as a perennial, would not have to be replanted from summer to summer. The phlox is listed in a 1909 book on American flower gardens as providing

> the brightest and most varied range of colours in any hardy perennial. Peculiarly appropriate since it is a native. Now to be had in white, pink, scarlet, mauve, and various combinations. Thrives anywhere. Propagate by seed, cuttings and division. . . .By cutting back can be made to flower any time.[5]

But Twachtman probably also chose the phlox for its aesthetic qualities—its vibrant colors, variety of forms, and its semblance of wildness. In *The Flower Garden*, he matches the image of wild and free-flowing flowers with an execution that expresses these very characteristics. Through physical manipulation of thick pigment directly on the canvas, he conveys the force of the wind surging through the floral masses. *Wildflowers* (pl. 2) depicts the same site as *The Flower*

fig. 9
John Henry Twachtman, *Winter Harmony*,
ca. early 1890s. Oil on canvas, 18 × 25 in.
(45.7 × 63.5 cm.). Spanierman Gallery,
New York.

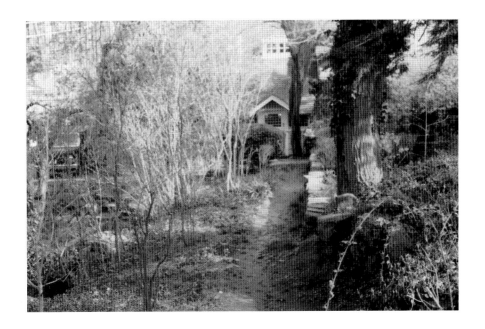

Garden but without the patch of ground and with blue rather than pink phlox. The works are very different in feeling. *Wildflowers* is much more sedate and orderly, with flowers arranged in a flat, screenlike pattern against the landscape. The petals of one red flower break up the soft blue-gray and light green palette. Twachtman delights in the irregular outline of flowers against the curving line that divides hills and sky. In *In the Sunlight*, the phlox flowers are confined to the verdant strip of landscape that surrounds the figure, yet they provide the brightest note and the most animated aspect of the painting. In *On the Terrace* (pl. 11), they appear much more prim, arranged in an orderly L-configuration, but they are actually unevenly spaced and each presents a differently shaped bulbous bloom.

In addition to phlox, it is apparent that Twachtman's garden included ordinary types of flowers, easily grown and tended, rather than those favored by Monet, who planted more exotic varieties such as Korean chrysanthemums and ruffle-crested strelitzias.[6] Tiger lilies, azaleas, irises, and gladioli are depicted in works in this exhibition, and we know from other catalogue listings that Twachtman also painted sweet william, fairy wand, wild aster, and goldenrod. There is, however, a common denominator in this selection. The flowers that Twachtman chose to paint and plant can be allowed a certain amount of wildness. Azaleas grow in great profusion, although they can be trimmed to form elegant shrubs; wild aster can be tended and planted in the garden, but as one writer noted, "the fields are full of Wild Asters, just as good and in some respects better."[7] Tiger lilies are one of the more common flowers that spring up on their own in the woods, and goldenrod are recognizable for their bright yellow blossoms and free movement across dry fields during the late summer.

In his preference for wildflowers in a natural setting, Twachtman was following the vogue for the wild garden, which had developed in America in the

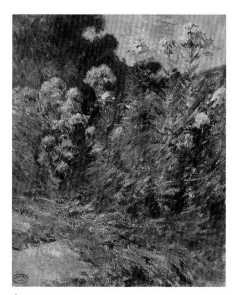

fig. 11
John Henry Twachtman, *The Flower Garden*,
ca. early 1890s. Oil on canvas, 27⅛ × 22¼ in.
(68.9 × 56.5 cm.). Museum of Fine Arts,
Brigham Young University, Provo, Utah.

late nineteenth century. Although deriving from the English picturesque garden, it was seen as a uniquely American form, characterized by untended nature, the planting of wild and indigenous flowers and plants within the garden plot, and the inclusion of already existing natural forms into the garden arrangement. As Helena Rutherfurd Ely wrote in 1911,

> The term "wild garden" may be descriptive of the garden made from native material without the cultivation of the soil, and as expressive of natural resources, as the terms of English garden or Italian garden, where the yews of England and cypress of Italy give at once the dominant note peculiar to the country where each is situated.[8]

As William Gerdts has recently shown, many American artists also celebrated the garden in a free and natural state.[9] Of all garden images by American artists, Childe Hassam's depictions of Celia Thaxter's wild garden on the island of Appledore off the Isles of Shoals are undoubtedly the best known (fig. 20). Twachtman may have been familiar with Thaxter's garden through the artists who spent summers on Appledore or from Hassam's paintings, although Hassam began to depict Thaxter's garden in the early 1890s—at the same time that Twachtman began to render his own garden. There is, moreover, an important distinction between the two gardens. Despite its apparent wildness, Thaxter's garden was well tended. She was a knowledgeable and avid gardener, and her book *An Island Garden* charts the daily and seasonal changes in her garden with enrapt detail.[10] The planning and thought that went into Thaxter's garden are evident in Hassam's paintings, which emphasize the sensitive careful arrangements of colors and shapes that Thaxter composed.

Throughout his Greenwich period, Twachtman's garden was probably much less tended, controlled, and refined. He did not, however, let it run rampant, and in fact he is known to have hired assistants.[11] His obituary in the *New York Times* also noted that "he was devoted to gardening."[12] Yet it seems likely that his approach was intuitive rather than based on research, study, and organized planning and was designed to give nature a relatively free rein. In Monet's garden at Giverny, by contrast, "Every item . . . was designed to play a part; even the straight furrows in the raked gravel of the paths were not a chance effect."[13] Monet had a head gardener and five under-gardeners and kept track of every detail of the garden, changing plantings to conform with particular viewpoints, carefully pruning withered blossoms, and reorganizing floral groupings to create patterned arrangements. As Claire Joyes has pointed out, Monet planned "his flower beds according to the principles that governed his palette, with light colours predominating and monochrome masses in juxtaposition."[14] Monet's primary concern in his garden was with relationships of color density and texture that facilitated his artistic expression. Twachtman preferred a garden that preserved the wildness of nature, and he organized it so that nature took precedence over considerations of the palette; he sought to mold his art to the expression of nature.

As his paintings reveal, Twachtman took great liberties with the garden subject, presenting it differently in every rendering. Although the garden paintings show virtually the same site, each seems to be set in a different landscape, conveying a unique sense of space and order. While he did not allow himself to depart from nature, he also did not permit a deviation from his own vision, and the tension in his work is the pull between the forces of self and nature. Changing perspective can also be found in his other subjects, but his depictions of flowers inspired the greatest variety in treatment and approach. Indeed, the diversity offered by the floral subject may have been what attracted Twachtman. It provided an opportunity for the expression of contrasting colors and textural variety as well as the interrelationship of disparate shapes. In fact, in the only extant account of Twachtman's advice to his students, he suggested that "If you naturally get things too cold, study flowers where warmth is concentrated. Monet walks in his garden and looks at the hearts of flowers until his eyes are saturated with color."[15] However much this statement demonstrates Twachtman's recognition of the optical concerns of the French painter, it also refers to his own desire to be immersed in nature.

Footnotes

[1] According to several sources, Twachtman settled in Greenwich in the fall of 1889. For further information, see Eliot Clark, *John Twachtman* (New York: Privately Printed, 1924), p. 27, and John Douglass Hale, *The Life and Creative Development of John H. Twachtman*, 2 vols., Ph.D. dissertation, Ohio State University, Columbus, 1957 (Ann Arbor: University Microfilms International, 1958), pp. 69–70. However, he probably lived initially as a tenant on the property, known as Hangroot, since he did not purchase it until 1890-91. The acquisition of the property was made in two installments; see Warantee Deeds, Greenwich Town Hall, 7 March 1890, Book 60, p. 236 (first purchase of land, 3-acre plot); 1 December 1891, Book 61, p. 488 (second purchase of land, 13.4-acre plot). See also Susan G. Larkin, "The Cos Cob Clapboard School," in *Connecticut and American Impressionism*, exh. cat. (Storrs, Conn.: The William Benton Museum of Art, University of Connecticut, 1980), p. 89.

[2] Discussions of the changes that Twachtman made to the house may be found in Alfred Henry Goodwin, "An Artist's Unspoiled Country Home," *Country Life in America* 8 (October 1905): 625–630, and John Douglass Hale, *The Life and Creative Development of John H. Twachtman*, pp. 72–76.

[3] Goodwin, "An Artist's Unspoiled Country Home," p. 629.

[4] Goodwin, p. 630.

[5] Neltje Blanchan, *The American Flower Garden* (New York: Doubleday, Page & Co., 1909), p. 63.

[6] See Claire Joyes, *Monet at Giverny* (London: Mathews Miller Dunbar, 1975); p. 38.

[7] Harriet Keeler, *Our Garden Flowers* (New York: Charles Scribner's Sons, 1910), p. 489.

[8] Helena Rutherfurd Ely, *The Practical Flower Garden* (New York: Macmillan Company, 1911), p. 165.

[9] William H. Gerdts, *Down Garden Paths: The Floral Environment in American Art*, exh. cat. (Rutherford, N.J.: Fairleigh Dickinson University Press [for the Montclair Art Museum, Montclair, N.J.], 1983).

[10] Celia Thaxter, *An Island Garden* (Boston: Houghton Mifflin Co., 1894).

[11] See Theodore Robinson's journal entry for 19 May 1894, in Theodore Robinson Diaries, Frick Art Reference Library, New York, in which he stated: "Twachtman busy engaged in gardening with his German Theodor and Er. the mulatto boy."

[12] "John H. Twachtman: Death of the Famous Landscape Painter at Gloucester, Mass.," *New York Times*, 9 August 1902, p. 9.

[13] Joyes, p. 37.

[14] Joyes, p. 37.

[15] Quoted in "An Art School at Cos Cob," *Art Interchange* 43 (September 1899): 57.

"Like Dreams of Flowers"

by William H. Gerdts

John H. Twachtman is so completely identified with the painting of landscape that it may come as something of a surprise that an exhibition would be even partially devoted to his exploration of the still-life theme. And it is true that, although such paintings and pastels are second in number only to his scenic work, they amount to only a small fraction of his total production. Twachtman *was* a painter of the landscape—*his* landscape especially—and in fact, his still-life painting and his figure work, too, are for the most part all interrelated in their expression of his own much-loved environment, in the most tender and gentle mode. The mature "complete Twachtman" is best understood through an examination of his work in the three artistic genres he investigated, especially during his years living and working at Greenwich and in nearby Cos Cob, where the pictorial realization of his own life-style and interests coincided with his finest and most individual achievements.

This coalescence of landscape and still-life painting is by no means inevitable. One could speculate on the nature of the still lifes that Twachtman's contemporary fellow landscapist, George Inness, might have painted, but in fact no still lifes are known by him. The finest still lifes created by Julian Alden Weir, Twachtman's close friend and colleague, were done before the two artists turned to an Impressionist-related aesthetic, after which still life appears to have become less crucial in the expression of Weir's creative urge. A painter such as Martin Johnson Heade was equally a still-life and a landscape painter, but his oeuvre in one genre really appears quite distinct from that of the other; if Heade's psychological and aesthetic drives inform both bodies of his work, they would appear to do so on quite different terms.

With Twachtman, the situation is very different. Despite the relative paucity of his still-life and figurative works, we approach them not only for their intrinsic beauty but also because they add immeasurably to the understanding of the total man and the total artist; perhaps we experience Twachtman even more through these pictures. Adding these two genres to the delicate, lovely landscapes with which we are already so familiar, we gain deeper insights into the man himself and what it is about *all* his art which makes it both so special and so appealing, as it has been since it was first created. Among all the first-generation American Impressionists, it was Twachtman whose painting most completely remained in both public and critical favor. And however few were the floral pictures he painted, they played a disproportionately large part in maintaining his visibility after his early death. In the decades after 1902, more of his flower paintings were on view than had been shown in exhibitions during his lifetime.

fig. 12
John Henry Twachtman, *Flowers*,
ca. 1889–1891. Pastel on paper, 19 × 15¼ in.
(48.3 × 37.7 cm.). National Museum of
American Art, Smithsonian Institution,
Washington, D.C., Gift of John Gellatly.

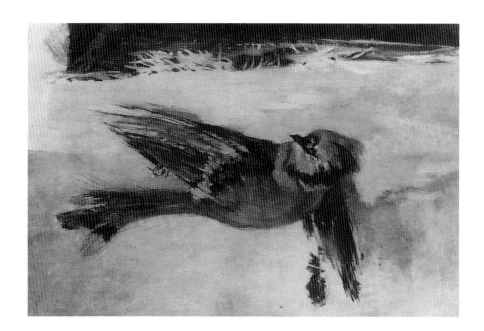

Twachtman scholarship is burdened with a number of difficulties which, though hardly unique, make the researcher's task more difficult than that for the majority of his contemporaries. One of these is the almost complete lack of dated works, and another is the similarity of titles and subjects of his pictures— a situation exacerbated by the assignment of alternate titles to the same works, perhaps by the artist himself and certainly by subsequent owners and dealers. Although these are factors that can affect conclusions concerning authenticity—and such problems are rampant—they have, at least so far, not caused such major difficulties with his still lifes as they have with his landscapes. But they do affect efforts to determine how prolific Twachtman was in the still-life and floral genres and whether located pictures are identical with those recorded in catalogues and reviews of earlier exhibitions, held during his lifetime or in the various one-man shows that took place during the three decades after his death.

We have a record of about sixty still lifes, mostly flower pictures and nature studies, which were exhibited from as early as 1871 through 1932, but many of these have similar or identical titles and almost surely represent the same works shown on different occasions. And the majority of Twachtman's located pictures of this nature can either be identified with those exhibited in the past or represent subjects which would allow for the possibility of such identification, even when an explicit association cannot be proven. Twachtman's pastel of *Irises* (pl. 19) is almost the only flower picture for which there appears no recorded early exhibition history. There are, of course, some recorded floral works that have not come to light and do not seem to suggest identification with located works, but all in all, there appears the strong possibility that the total floral production of the artist may not have exceeded some twenty-five to thirty works.

And yet, what variety exists within that quite tiny oeuvre, especially when one considers all the categories of still life that Twachtman ignored or quickly discarded! He was obviously not drawn at all toward the pictorial rendering of man-made objects, costly bric-a-brac, or even the elegant ceramic, metal, or glass containers that were painted so lovingly by his friend Weir; and trompe l'oeil illusionism seems to have appealed to him not at all. The kitchen picture, depicting meats and vegetables and useful utensils, and the related piscatorial and dead game subjects depicted so skillfully by his contemporaries William Merritt Chase and Emil Carlsen—both genres critically acclaimed and popular in their day—were not for Twachtman. He did, however, paint a single dead bird, but, typically, it was a small blue jay (fig. 13) rather than one of Carlsen's monumental swans. Even the most traditional themes of all, arrangements of fruit and formal bouquets of flowers, appear to have been investigated only once each by the artist and then abandoned (pl. 8).

Flowers and related natural growing plants were nevertheless Twachtman's subject, but he much preferred to depict them still rising from the soil. They grow in tangled masses—and not just lovely colorful blooms but also wild-flowers and blossoming weeds and herbs. Vegetables do not appear in still lifes but as living, growing entities, as in *The Cabbage Patch* (pl. 4) or *Tobacco Patch* (fig. 14), if indeed, these are the plants that are here being cultivated. Twachtman also painted flowering bushes and shrubs, more formal gardens, and scenes in the conservatory, where the flowers grew under more controlled conditions. And though the two-part nature of the present exhibition comes together in the overall ethos they project, it does so in a direct pictorial manner, in the depictions of members of his family surrounded by flowers, projecting not glorious spectacle so much as shared beauty and contentment.

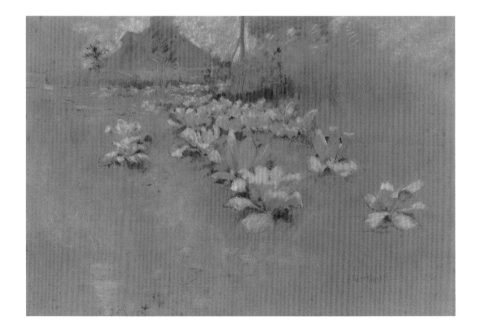

fig. 14
John Henry Twachtman, *Tobacco Patch*, ca. early 1890s. Pastel on paper, 14 × 21 in. (35.6 × 53.3 cm.). North Carolina Museum of Art, Raleigh, Gift in memory of Katherine Clark Pendleton Arrington (from her own collection) by her nephew and niece, Mr. and Mrs. Fabius B. Pendleton.

Twachtman showed still lifes at the beginning of his career in Cincinnati: a picture of *Flowers* appeared in a display of student work in 1871 at the McMicken School of Design, which he had entered that year after previous study at the Ohio Mechanics Institute; four years later, he also exhibited a *Still Life* there.[1] The location and even the appearance of these are not known, and it is most probable that they were student exercises provided and/or assigned by one of the McMicken instructors, perhaps the director, Thomas S. Noble, rather than representing a purposeful thematic selection on the young neophyte's part. The floral work, done "from the flat" in the Night School, was nevertheless an unusual choice of subject, since most of Twachtman's fellow students displayed classical themes or figural subjects, often after a work by one of the Old Masters. Twachtman was, however, not alone in showing a floral subject, which maintained its traditional appeal to a number of the women exhibitors and was also the subject of one of the display pieces shown that year by Kenyon Cox, who was then a student in the Day School. The theme of the unlocated *Still Life* exhibited in 1875 is unknown, though a fruit arrangement is most probable; in any case, it is likely, after so many years of training, to have been a painting rather than a drawing, since Twachtman had begun exhibiting landscapes professionally at the Cincinnati Industrial Exposition in 1873. The *Still Life*'s aesthetic was surely informed, in part, by Twachtman's resumption of study at the Ohio Mechanics Institute, where he had joined a class taught in 1874–1875 by Frank Duveneck, lately returned from Munich.

Later in 1875, Twachtman went to Munich with Duveneck and became one of the standard-bearers of the radical Munich style of the mid-1870s both abroad and back home, until about 1882. The following year he returned to Europe, this time to France, where he remained until the end of 1885, but he sent a group of twenty pictures to Boston early that last year, where they were displayed in February at J. Eastman Chase's Gallery. Two of these—again unlocated—were on the increasingly popular garden theme, *A French Garden* and *Garden Scene*, both of which included figures. *A French Garden*, an extraordinarily large work for Twachtman, was subsequently entered into the widely heralded First Prize Fund Exhibition held at the American Art Association in New York in April 1885, but it failed to become a prizewinner or, with one exception, even to attract significant critical attention. The picture was retitled *A Garden in Normandy* when the Prize Fund paintings were shown at the Southern Exposition in Louisville later that year.

A French Garden was ecstatically received by the critic of the *Boston Evening Transcript*, who found it the embodiment of all that was admirable in Twachtman's work, especially his sensitiveness to poetic impression and feeling for subtle, varying color.[2] When the painting was shown in New York, the ever-sagacious Clarence Cook, in the *Studio*, regarded it both ambiguously and curiously: "Here is the salvation of talent and sincerity that, even when the result of its labor is all a mistake, we feel the presence of qualities that make it respectable. Here everything is wrong; an ugly church is unpleasantly conspic-

uous, dominates the picture, indeed; there are unreal trees, impossible earth, and an atmosphere to suit. But while we reject it, and are sorry for it, we know that the artist is there who has proved himself an artist, and who will prove himself such again. He is trying experiments as is Mr. Alden Weir, and both the men can afford to do it, as we can afford to stand by and wait for what will come of it."[3] The Boston critic, too, had found that "the figure seems rather to jar a little," and neither writer paid much attention to the actual garden aspect of the work, though the *Transcript* author admired "the bright-pink roses, the fluffy masses of cream-white flowers."[4]

These two garden scenes may or may not have been visual precursors of some of the figural works that Twachtman was later to paint on his own Connecticut homestead, but they would both have been French pictures and undoubtedly revealed the impact of influences absorbed from his immediate experiences abroad, however much they were also informed by the artist's very personal interpretation. He was not to "go public" with floral pictures again until 1889, but by that time a series of interconnecting occurrences had radically changed both the artist's aesthetic and his life-style.

After returning to this country in the winter of 1885–1886, Twachtman, despite a period of economic hardship, began to locate himself in the Greenwich–Cos Cob area of southern Connecticut, not far from J. Alden Weir in Branchville. At first renting, he finally settled in the autumn of 1889 on a seventeen-acre farm outside of Greenwich, which he purchased in 1890–1891 with monies he had accumulated after working on a cyclorama project and from a successful exhibition the previous year; he also had the assurance of a steady income derived from the teaching he had begun that fall at New York's Art Students League. During these years, Twachtman also rejoined the more avant-garde New York painters, contributing to the annual shows of the Society of American Artists. Moreover, in 1888, he began to participate actively in the Society of Painters in Pastel, a group of American artists who were exploring that medium, which was undergoing a renaissance of artistic interest on both sides of the Atlantic, under the impetus of the work of Jean-François Millet and especially of Whistler. The Society had held its initial exhibition in 1884, but it was not until 1888 that a second show was organized, with Twachtman as a significant contributor.[5]

In that 1888 exhibition, Twachtman exhibited primarily Venetian and Dutch scenes, indicating that he may have begun investigating the pastel medium several years earlier; certainly there were a considerable number of pastels shown in his second one-man show, held at J. Eastman Chase's Gallery in Boston in January 1886, though none of these would appear to have fallen into the category of still life. Although Twachtman returned from Cincinnati to join Duveneck in Florence in November 1880, there is no sure indication that he had previously made contact with Whistler in Venice, as had other Duveneck students. They had met the great expatriate in Venice earlier that year, when Whistler was actively engaged with his most famous series of pastels. Yet it was

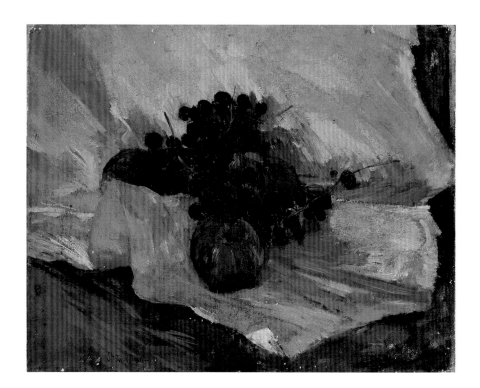

fig. 15
John Henry Twachtman, *Apples and Grapes*, ca. 1889. Oil on canvas, 20⅜ × 16⅜ in. (51.8 × 41.6 cm.). Collection of Anna Ely Smith and Lyn Ely.

Twachtman, more than any other American practitioner of the medium, who adopted a Whistlerian aesthetic in the pastel medium—the use of a dark-toned, usually brown paper, often left almost totally bare, with only flecks and fragments of drawing and color to indicate the artist's impression of his theme. In this way, he gained in spontaneity what he sacrificed in form.[6]

Indeed, the increasing popularity of the pastel medium, not only among more advanced painters but also among growing numbers of art critics, has been seen as one factor in the surprisingly swift acceptance of the Impressionist style in America. Beginning in 1889, the more "finished" oil paintings of the same artists who had so effectively utilized the sketchy pastel medium prepared the way for Impressionism in the exhibitions of such organizations as the Society of American Artists. Pastel also may have helped ease Twachtman's personal adaptation of that aesthetic in oil painting, as practiced in his new and much-loved surroundings at Greenwich. Certainly his constant use of a toned background on which he laid his lighter colored paints directly parallels his experience with pastel, as does his very careful drying out of the completed paintings by laying them in bright sunlight, so that they achieved that more chalky surface appearance which is unique in his work.[7]

Pastel was, for Twachtman, a major "minor" medium—one he practiced with great enjoyment, examples of which he displayed publicly in almost all of his one- and two-man exhibitions throughout his lifetime. Perhaps the most successful of these was the auction he shared with Weir, held by Ortgies & Co. in New York at the Fifth Avenue Art Galleries in February 1889. It is significant that the single "nature study," his *Wild Flowers*, marks his first known display of

the kind of floral piece with which he has come especially to be associated, and that the work was in the medium of pastel, commended by the critic of the *New-York Daily Tribune* for its "fine, decorative feeling."[8] In the same exhibition he showed an oil painting of *Apples and Grapes*, a more formal and traditional still life in both subject and composition, but a theme and approach that he appears to have immediately abandoned (fig. 15).

Apples and Grapes not only represented a traditional form of still life that held little interest for Twachtman, but it embodied an objectivity that was foreign to his whole artistic production, and never more so than during his Greenwich period of 1889–1900. *Wild Flowers*, by contrast, must have embodied that sensitive reaction to the humble and casual in nature to which Twachtman was so very attuned. Given the picture's recorded dimensions of 17 × 20 inches, it is unlikely that it can be identified with Twachtman's located wildflower pastels, nor can one be certain that it was the same picture that was displayed two months later, in April 1889, at the third exhibition of the Society of Painters in Pastel. Twachtman's paintings are known to have dominated that show numerically, with all but one being landscapes. That one exception, *Wild Flowers*, was described as "a nicely composed impression, with tall flowers placed as accents in a bit of landscape."[9]

The Society held its fourth and final exhibition in 1890, again with a large representation by Twachtman. This time all of his pictures may have been landscapes. One reviewer contrasted Twachtman's extremely summary landscapes with portrait and flower studies, but it is not clear if these latter were by Twachtman himself or one of his colleagues, and no catalogue for the show has been located.[10] But it was again Clarence Cook, now far surer of Twachtman's individual genius than he had been five years earlier, who, in reviewing the show, defined the artist's unique sensibility, an analysis equally applicable to his landscapes and flower pictures:

> Mr. J. H. Twachtman carries off the honors in the landscape portion of the exhibition. . . .[T]here is a spirit in Mr. Twachtman [which] holds him in a world apart; he is the Shelley of our painting; incommunicable, elusive, seeing ever the soul of the landscape as clearly as others see its body, and making us, even against our will see it too and come to love it more than the reality. Compared with this artist's clear vision, Corot is coarse, and Monet clumsy; yet his study is founded as firmly on reality as theirs. He seems to be of purer fire, and in his ardor to have almost touched the goal for which these other poets of the brush are striving.[11]

Once settled in his home in Greenwich, the house and the grounds became the focus of Twachtman's pictorial as well as his emotional attention. This totality constituted his sheltering, protective environment, offering both security and familial affection. It was with ease that he could extend his territorial commitments to the Holley House at Cos Cob, where he taught in the summers, just as the Holley House and his home could become a welcome place of

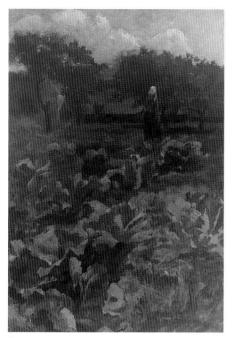

fig. 16
Theodore Robinson, *Cabbage Patch*. Oil on
canvas, 14 × 9⅝ in. (35.6 × 24.2 cm.).
Private Collection. Photograph courtesy of
Meredith Long & Company, Houston.

congregation for his fellow artists such as Weir and Theodore Robinson (fig. 16).
But Twachtman's devotion to his private habitat also accounts for the contrast
between the affection he displayed at Holley House and his recognized disdain
for his classes at the Art Students League in New York.

His devotion to his piece of terra firma led him not only to depict the house,
gardens, brook, and Horseneck Falls over and over again, documenting his
additions to the home as the family grew—the building of a bridge over the
water and the development of the gardens—but also to record the same scenes
repeatedly at different times of the year. These were not traditional Impres-
sionist studies of changing conditions of light and atmosphere, but paeans of
affection to that very intimate landscape which was his own. This sensibility also
accounts for his increasing, though limited, involvement with paintings of the
flowers and allied subject matter, weeds and herbs, that grew on his property
and which were never too inconsequential for his brush or chalks. The least
fragile growth constituted a part of the totality of his environment, and any
attempt to comprehend the nature of Twachtman's Greenwich experience
misses the point if these works, and the paintings of his family within that
setting, are disregarded.

The pictorial results of Twachtman's immersion in his *sancta sanctorum*
emerged in the paintings shown in his one-man exhibition held in March 1891 at
the Wunderlich Gallery in New York. No foreign scenes were included; instead,
the titles of the works and identified paintings indicate that he drew upon his
intimate setting, and among the pastels—over thirty of the forty-three pictures
shown—five were floral and herbal nature studies. These suggest not carefully
cultivated flowers or garden scenes, but studies spontaneously drawn of casual,
natural plant forms, from fragile ageratum and thoroughwort to the more hardy
and seemingly favorite flower, the tiger lily (no. 33, *Red Aggeratum* [sic]; no. 34,
Wild Aster; no. 35, *Thoroughwort*; no. 36, *Aggeratum* [sic]; no. 40 *Tiger Lilies*),
the latter probably the pastel of that subject now in the collection of the National
Museum of American Art (pl. 15). That these pastels were characterized by an
aesthetic of Whistlerian fragility is confirmed by the critic for the *Magazine of
Art*, who noted that Twachtman's "flower pieces are like dreams of flowers."[12]
These works were admired, too, by the critic for the *Art Amateur*: "The
certainty of the painter's touch was most remarkable in several sketches of wild
flowers, of apparently the slightest description, yet recognizable at a glance."[13]

It is possible that *The Meadow*, the now unlocated or unidentified oil which
Twachtman exhibited in the Wunderlich show, may also have contained wild-
flowers and may have been similar or identical to the painting which had been
reproduced as an illustration for G. Melville Upton's poem "The Season's
Boon" in *Scribner's Magazine* in August 1890 (fig. 17).[14] William A. Coffin noted
little over a year later that such illustrations were "familiar to readers of
SCRIBNER'S. Mr. Twachtman is especially successful in making a beautiful
page with the simplest of motives, a few wild flowers growing in the foreground
of a meadow . . . given with exquisite refinement and subtile [sic] skill."[15]

Such themes continued to draw Twachtman's attention. He wrote to J. Alden Weir from Greenwich in September 1892 that "The foliage is changing and the wild-flowers are finer than ever. There is greater delicacy in the atmosphere."[16] And in May 1893 seven oils and pastels of flowers and herbal growths appeared in the much heralded two-artist exhibition Twachtman shared with Weir at the American Art Galleries. The display attracted tremendous critical attention, for it confirmed the allegiance of two of the country's leading young artists to the Impressionist movement. But it also allowed the public to compare the work of home-grown Impressionists with two European ones, for the gallery was holding a simultaneous exhibition of the paintings of Claude Monet and Paul Albert Besnard, and comparisons were inevitable.

Though this turned out to be the largest showing of Twachtman's flower and nature studies ever assembled before the present exhibition, these themes were ignored by the critics, who focused rather on the radical aesthetic espoused by the simultaneous shows and the comparative merits of indigenous and foreign talent. All of the floral and herbal pastels—no. 34, *Wild Aster*; no. 38, *Thoroughwort*; no. 39, *Red Aggeratum* [sic]; and no. 43, *Tiger Lilies*—may have been those that Twachtman had exhibited two years earlier. But he had now turned his attention to painting these themes in oils—no. 10, *Golden Rod and Wild Aster*, and no. 26, *Tiger Lilies*, subjects he had already recorded in the more fragile and spontaneous pastel medium. It is quite likely, in fact, that no. 26 is one of two extant paintings entitled *Tiger Lilies* (pl. 3, fig. 8), and it is possible that his well-known *Meadow Flowers* (pl. 1) is the present title of no. 10.

The theme of the still-growing flower and the nature study were not, of course, novel conceptions in American art. Such a pictorial approach to the rendering of flowers, weeds, grasses, herbs, and the like had already been championed by the influential English aesthetician John Ruskin during the 1850s and had inspired a whole group of young American artists—the "American Pre-Raphaelites"—who had picked upon precisely that aspect of Ruskin's dicta and English Pre-Raphaelite technique, while ignoring for the most part the movement's moralizing objectives (fig. 18).[17] Of course, Ruskin's doctrine of detailed "truth to nature" was completely antithetical to Twachtman's elusive sketchiness, as it also had been to the work of Whistler, which ultimately provided a primary inspiration for Twachtman's painting.

Other Americans, such as the Philadelphia flower painter George Lambdin, also concentrated upon still-growing floral blooms, but even Lambdin's pictures are far more botanically precise as well as more artfully planned than are Twachtman's. But there were those among Twachtman's own generation, active precisely at the same period that he was investigating this theme, who undertook floral pictures in which the viewer was seemingly plunged, head-on, into the world of nature. Maria Oakey Dewing's *Garden in May* of 1895 (fig. 19), and Childe Hassam's magnificent renderings of Celia Thaxter's garden on Appledore, one of the Isles of Shoals, painted in the early 1890s (fig. 20), share a kinship with Twachtman's oils and pastels of growing flowers and herbs.

fig. 17
John Henry Twachtman, illustration accompanying a poem by G. Melville Upton, "The Season's Boon," *Scribner's Magazine*, August 1890, p. 223. Engraved by Norman William Kingsley. Photograph courtesy of Princeton University Library, Department of Rare Books and Special Collections.

fig. 18
Fidelia Bridges, *Milkweeds*, 1861. Watercolor,
16 × 9½ in. (40.6 × 24.1 cm.). Munson-
Williams-Proctor Institute, Utica, New York.

Even here, however, Twachtman seems more at one with nature. Hassam's paintings, for all their informality, depict a garden, albeit a consciously "wild garden," a reaction against excessive formality which was both praised and criticized by Celia Thaxter's friends. And Hassam also remains conscious of a "sense of place"—the position of the flower beds vis-à-vis the ocean and the configuration of the island landscape in which he was working, thus giving a semblance of calculated composition. Dewing's paintings are more flamboyant and sensuous, but she never abandons her role as botanist as well as artist, and though she was hardly a Ruskinian, her works reveal the mark of cultivation and the supervision of the gardener.

Twachtman's paintings of field and wildflowers were admired in their own day and remained so after his death. In his estate sale, held on 24 March 1903, at the American Art Galleries in New York, the pastels of *Wild Flowers* and *Meadow Flowers* were praised by the critic of the *New-York Daily Tribune*: "In all these things we get some casual bit of nature captured in its most artless aspect with the most searching sympathy and with wonderful precision, the truth which fills each transcript being made the more charming as it is made the more vivid by the ever present note of style."[18] The *Art Interchange* critic wrote that "Twachtman's pastels of field flowers are also modest attestations to his merit as an artist. Almost like flowers, they float in atmosphere, decorative and exquisite."[19]

Nor were these works forgotten in the years after Twachtman's death, thanks in part to their reappearance in a series of exhibitions of the artist's works: *Phlox* in a show at Knoedler Galleries in January 1904; three floral works at the Lotos Club in 1907; four floral oils and two pastels at the New York School of Design for Women in January 1913, three of which traveled to Buffalo for

fig. 19
Maria Oakey Dewing, *Garden in May*, 1895.
Oil on canvas, 23⅝ × 32½ in. (60 × 82.6
cm.). National Museum of American Art,
Smithsonian Institution, Washington, D.C.,
Gift of John Gellatly.

fig. 20
Childe Hassam, *Poppies, Isles of Shoals*, 1892.
Oil on canvas, 19¾ × 24 in. (50.2 x 61 cm.).
Collection of Mr. and Mrs. Raymond J.
Horowitz.

inclusion in a Twachtman show that March; and five flower pieces shown in the Twachtman room of the Panama-Pacific International Exposition in San Francisco in 1915.

Four years later, Eliot Clark wrote in an article that he admired "the painted flowers of the field [which] seem imbued with the delicacy of their own nature."[20] And in his 1924 monograph, he expanded upon his admiration for Twachtman's floral pieces, especially those done in pastel. Having noted the origins of this interest in the foreground field flowers and grasses introduced into some of the artist's French works (such as *Arques-la-Bataille*), Clark considered that "most personal and unique are the exquisite studies of field flowers." He went on to point out:

> In the pastels the flowers become the subject. Drawn against a background of neutral toned paper, the color is rendered in delicate harmonies, the form lightly and deftly suggested. Unstudied in composition, without apparent arrangement, the flowers of the field seem to radiate something of their own wild but exquisite nature. In no other form has Twachtman registered a more personal expression. Not conventionally decorative or striking in effect, these delicate studies are a beautiful tribute to the subject and the medium in which they are manifested.[21]

This is not to say that all of Twachtman's floral works involve the uninhibited splendor of his *Tiger Lilies* or the wild fragility of his meadow flowers and his herbal nature studies. In fact, it may well be that no. 27 in the 1893 American Art

Galleries show, *Gladiolus*, can be identified with one of Twachtman's two known formal still lifes, the work now known merely as *Flowers* (pl. 8), in the collection of the Pennsylvania Academy of the Fine Arts. In this picture, the dominant flower is indeed the gladiolus, a flower which appears only once again in early Twachtman exhibition records, when the artist's *Gladioli* was exhibited in the gallery devoted to his work at the Panama-Pacific International Exposition. At that time, it was lent by Edward H. Coates, whose widow donated the picture to the Pennsylvania Academy.

In Twachtman's sole bouquet, the flowers are lovingly rendered, the artist contrasting the exuberance of the gladioli with the basic ethereality of his vision. But he was obviously less secure with the need to reconcile these factors with the traditional forms of vase and supporting table and the construction of convincing spatial ambience. Yet Twachtman's art, including his floral pictures, was to become more domesticized in the succeeding years; in this transition, the ebullience of youth may have been replaced by greater orientation to home and family. As he appears to have exhibited no more pure flower paintings, wild, herbal or otherwise, during his lifetime, we cannot be sure if he continued to paint such pictures. Many in both oil and pastel were shown in the half-dozen one-man exhibitions held in the decade and a half after his death. Some bear already familiar titles such as *Tiger Lilies* and *Wild Flowers*, and others, *Phlox, Pink Phlox, Marigold* and *Swamp Flowers*, may be either variants of works already known, other pictures painted in the early 1890s, or later works by the artist. *Pink Phlox*, shown in the Lotos Club exhibition held in January 1907, was

owned by Twachtman's close colleague, J. Alden Weir, who probably purchased it from Twachtman's 1903 estate sale, along with the pastel of *Wild Flowers*, and is probably identical with the exuberant *Flower Garden* (fig. 11), a dynamic work very much in the spirit of the artist's several renderings of tiger lilies.

But it seems likely that, by and large, Twachtman's more domesticated floral renderings succeeded the pictures of wildflowers. These comprise several kinds of compositions. There was his growing concern for garden cultivation, displayed in pictures such as *Pink Flowers* (fig. 21) and *In the Greenhouse* (pl. 5). In the latter, the rows of circular containers define a spatial construction; in *Pink Flowers* the space is defined by the wooden separations that create a pathway around the plants, though the combination here of an overhead view and the strong, plunging angular position of the planters imposes a dynamic thrust upon the composition.

More common are Twachtman's paintings of his garden seen vis-à-vis his house and barn, with floral bushes bordering the pathway to the door, sometimes emphasized by potted plants, as in *Hollyhocks* (location unknown), *A Garden Path* (pl. 7), *In the Garden* (fig. 22), and the best-known of these, *Azaleas* (pl. 6). Several such paintings were exhibited during Twachtman's lifetime, although it is difficult to corroborate whether they are among those known today; *My House and Garden* was shown at the American Art Association exhibition of 1893 and also appeared that year at the St. Botolph Club, while another work titled *Garden Path*, possibly *Azaleas*, was on display at the St. Botolph in 1899. Not surprisingly, these relatively structured pictures are rendered in oil, for the spontaneity of pastel would have been inappropriate for these more elaborate works, which must, in part, have been studio creations.

Almost surely all the above-named pictures relate to flower gardens, but Twachtman also depicted a few more utilitarian garden scenes—the pastels of *Trees in a Nursery* (pl. 18) and *Tobacco Patch* (fig. 14), both of which may actually predate his Greenwich residence, and the marvelous oil *The Cabbage Patch* (pl. 4). This, one of the artist's most complex arrangements of layered bands of growing flowers and vegetables, juxtaposed with large potted plants and a garden fence, behind which looms the structure of the artist's home, bespeaks both a domesticization and a utilitarian purpose for the garden that was unusual in his painting. Yet the theme here may do more than recreate the actuality of Twachtman's environment. If these are actually cabbages, they recall a favorite subject undertaken by both American and European artists, including his good friend Theodore Robinson, during Twachtman's years of training. For if the most popular theme of the 1870s and 1880s for painters of all nationalities working abroad was the peasant, then the most common environment for those figures was the cabbage patch and cabbage garden—the rudimental peasant food, seemingly as essential for the artists as for the subjects themselves.

Ultimately, the garden became just one very important component of Twachtman's life with his family on his Greenwich homestead. And among his most effective renderings of floral imagery are those in which the growing

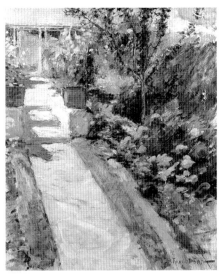

fig. 22
John Henry Twachtman, *In the Garden*, ca. late 1890s. Oil on canvas, 30 × 25 in. (76.2 × 63.5 cm.). Private Collection. Photograph courtesy of Vose Galleries, Boston.

blooms are combined with his home and his wife and children, as in *In the Sunlight* (pl. 9) and *On the Terrace* (pl. 11). The profuse floral borders create a delicate, upright structure to surround the softer, more curvilinear forms of the figures and add glowing colorism to these scenes of domestic tranquility. They are as integral to Twachtman's pictorial achievement as they are to the environment of which they are a part.

On the Terrace was the only one of Twachtman's floral works to appear in any exhibitions of the Ten American Painters, the group which he helped to found in 1897 and which held annual exhibitions for two decades beginning in 1898. Twachtman, of course, died in 1902; his work was shown posthumously in the 1903 and 1904 exhibitions; his place was taken by William Merritt Chase beginning in 1906. In 1898, *On the Terrace* garnered especially laudatory reviews, the critic for the *New York Sun* finding that among the selection: "the one containing most of the true feeling of out of doors is the view in a garden with figures in white."[22] The writer for the *New York Evening Post* was even more fulsome:

> Notice, for instance, the admirable arrangement of the picture called "On the Terrace" (No. 35), the placing of the flowers in the foreground, the house in the background, and the group of the white figures as a mass or spot of light in the middle distance. It is absolutey [sic] true in tone and values, true also in drawing; but, aside from its truth or falsity; how beautiful again it is as decoration! This decorative quality is the last thing that people look at in a picture, and yet it should be the first thing. If a picture is not pleasing to the eye, then it has missed in the primary requirements of pictorial art.[23]

That this amalgam of the floral environment with his home and family were essential ingredients of both Twachtman's life and art was perceptively recognized some sixteen years after the artist's death by the astute art writer and critic, Charles de Kay. De Kay spoke of the varied nature of Twachtman's better-known landscapes, but then went on to discuss the artist's rare figure paintings. "A notable instance [*On the Terrace*] is the portrait of his wife and her children in the Gellatly collection. She is seated before the low-pitched home among her flower-beds; it is hard to say which is more charming, the group of mother and children or the masses of growing flowers. A solidarity seems established between the two. Nor is the house negligible in its picturesque value as a background. Without seeing this picture one can scarcely get a rounded idea of the artist." And in regard to Twachtman's pure floral pieces, de Kay went on to ask: "With the exception of John La Farge what modern has surpassed this artist in the painting of flowers? Unfortunately the wider circle of amateurs and picture buyers does not greatly care for flower pieces or indeed for still-life generally. And yet—many is the Salon, many is the Academy Show in which the highest talent presented and the finest, loveliest paintings shown were just the still-life and flower pieces—modest, sweet-voiced, unambitious."[24]

Footnotes

1 I am grateful to Lisa Peters for locating the records of these earliest exhibited still lifes by Twachtman, and also for her help in regard to the reviews which mention his still-life and floral work.

2 "Art Notes: Mr. Twachtman's Landscapes," *Boston Evening Transcript*, 17 February 1885, p. 2.

3 [Clarence Cook], "American Art-Association," *Studio*, n.s. 1, No. 19 (25 April 1885): 225.

4 "Art Notes," *Boston Evening Transcript*, p. 2.

5 For a discussion of the Society, see Dianne H. Pilgrim, "The Revival of Pastels in Nineteenth-Century America: The Society of Painters in Pastel," *American Art Journal* 10 (November 1978): 43–62 and Carolyn Querbes Nelson, "The Society of Painters in Pastel, 1884–1890," M.A. thesis, University of Texas at Austin, 1983.

6 On Whistler's Venetian pastels, see Robert Harold Getscher, *Whistler and Venice*, Ph.D. dissertation, Case Western Reserve University, Cleveland, 1970 (Ann Arbor: University Microfilms International, 1971), pp. 101–140.

7 John Douglass Hale, *The Life and Creative Development of John H. Twachtman*, 2 vols., Ph.D. dissertation, Ohio State University, Columbus, 1957 (Ann Arbor: University Microfilms International, 1958), pp. 211ff.

8 "Pictures by Messrs. Weir and Twachtman," *New-York Daily Tribune*, 7 February 1889, p. 7.

9 "Monthly Record of American Art, *Magazine of Art* 12 (June 1889): xxvi.

10 "Art Notes," *New York Evening Post*, 2 May 1890, p. 6.

11 [Clarence Cook], "The Painters in Pastel. The Fourth Exhibition," *Studio* 5 (17 May 1890): 238.

12 "Monthly Record of American Art," *Magazine of Art* 14 (June 1891): xxvii.

13 "My Notebook," *Art Amateur* 24 (April 1891): 116.

14 *Scribner's Magazine* 8 (August 1890): 223.

15 William A. Coffin, "American Illustration of To-Day," *Scribner's Magazine* 11 (February 1892): 198–199.

16 [John H.] Twachtman, Greenwich, [Conn.] to [J. Alden] Weir [Branchville, Conn.], 26 September 1892, Weir Family Papers, MSS 41, Harold B. Lee Library, Archives and Manuscripts, Brigham Young University, Provo, Utah. Quoted in Richard J. Boyle, *John Twachtman* (New York: Watson-Guptill, 1979), p. 52.

17 For details concerning the American Pre-Raphaelites, see *The New Path: Ruskin and the American Pre-Raphaelites*, exh. cat. (Brooklyn: Brooklyn Museum, 1985), with essays by Linda S. Ferber, William H. Gerdts, Kathleen A. Foster and Susan P. Casteras.

18 "Art Exhibitions: The Twachtman, Colman and Burritt Collections," *New-York Daily Tribune*, 21 March 1903, p. 9.

19 "At the Galleries," *Art Interchange* 86 (May 1903): 116.

20 Eliot Clark, "John Henry Twachtman (1853–1902)," *Art in America* 7 (April 1919): 137.

21 Eliot Clark, *John Twachtman* (New York: Privately Printed, 1924), pp. 63–64.

22 "Art Notes: Exhibition by Ten American Painters at Durand-Ruel Galleries," *New York Sun*, 30 March 1898, p. 6.

23 "Ten American Painters," *New York Evening Post*, 1 April 1898, p. 7.

24 Charles de Kay, "John H. Twachtman," *Arts and Decoration* 9 (June 1918): 76.

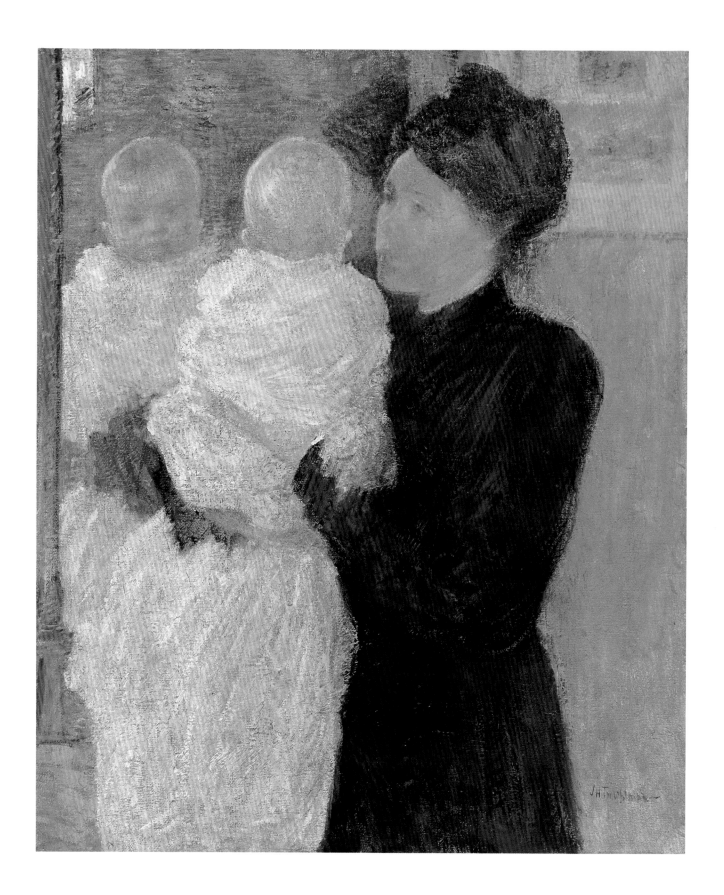

Twachtman in Greenwich: The Figures

by John Douglass Hale

Twachtman the figure painter, the portraitist? The name John Henry Twacht-man brings to mind landscapes, more than likely winter scenes, for which he had displayed an unusual sensitivity, or waterscapes—according to Twacht-man's eldest son, J. Alden, the family home on Round Hill Road in Greenwich was purchased for the sake of the little waterfall gracing the brook that wound its way through the surrounding farm land.

However, Twachtman was trained at the Royal Academy in Munich, where working from the figure was stressed, and Munich graduates were especially admired for their ability in painting the model, nude or clad in exotic costumes, as can be seen in the canvases by Twachtman's close friends Frank Duveneck and William Merritt Chase. Portrait painting was also a subject taught in Munich, and Twachtman did at least one work in this genre during the period, painted in the dark Rembrandtesque tones of Munich and displaying the realism for which the school was known (fig. 24). He also created another portrait in the Munich style, a depiction of his wife, Martha Scudder, painted in 1881, the year they were married (fig. 25). Twachtman obviously took great pleasure in the portrait of his wife, setting it in an ornate Renaissance frame (in which it is still framed today), and the work hung throughout the Greenwich years in the living room of the Twachtman home. A photograph from the Alfred Henry Goodwin 1905 article on the house shows it displayed prominently above the fireplace (fig. 26).[1]

At the Académie Julian in Paris in the mid-1880s, drawing from the figure was again the only choice. Twachtman's teachers were the Ecole des Beaux-Arts masters Jules-Joseph Lefebvre and Gustave Boulanger. "I am drawing from the figure, nude, this winter and you know how much I need drawing," Twachtman wrote to his friend J. Alden Weir from Paris during his French years.[2] When the architect Stanford White visited Twachtman in Paris in 1884, he also com-mented that Twachtman was "hard at work—*drawing*—slavery—I should think to him—but a slavery he will never regret—he is delighted with his life in Paris."[3] Yet only landscape paintings are extant from Twachtman's experi-ence in France, those moody, often melancholy oils that contrast greatly with his later work.

Twachtman returned to the figural subject during his Greenwich years. However, compared to the landscapes created during the period, figure paint-ings are extremely rare. In addition to the six paintings of the subject in this

fig. 23
John Henry Twachtman, *Mother and Child*, ca. mid-1890s. Oil on canvas, 30⅛ × 25⅛ in. (76.5 × 63.8 cm.). The Fine Arts Museums of San Francisco, Jacob Stern Family Loan Collection.

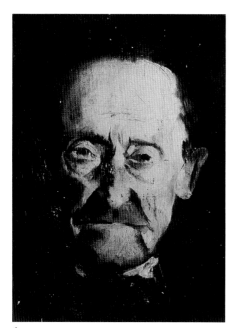

fig. 24
John Henry Twachtman, *Head of a Man*,
before 1878. Oil on cardboard,
14½ × 10¾ in. (36.8 × 27.3 cm.).
Cincinnati Art Museum, Gift of
Mrs. Elsi Storz.

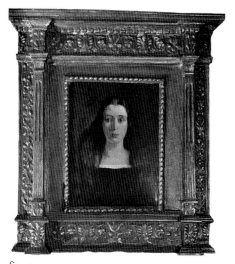

fig. 25
John Henry Twachtman, *Portrait of My Wife*,
1881. Oil on canvas, 12 × 9¾ in.
(30.5 × 24.8 cm.). Private Collection.

exhibition, there are only two other located works. Twachtman did not seek to hone his talents at figural rendering as did other artists during his era. He did not hire professional models and was not interested in traditional poses and in creating the careful studies advocated in academic ateliers. As he told his students in 1899, "If you are working from the figure do not do the conventional sort of thing that we find in a sketch-class model, but rather the unconscious attitude. The charm of childhood lies in its unconsciousness. Do we like people who pose? No. A figure that is obviously arranged affects one in the same way. Wherever you go watch attitudes and remember them for future use."[4]

All of Twachtman's figure paintings portray his wife and children, and his rendering of the subject is directly linked to his pleasure in his family. Three children had been born before the family moved to Greenwich—John Alden in 1882 (named for his father and for Julian Alden Weir), Marjorie (in Paris) in 1884, and Elsie in 1886. These three are undoubtedly the children standing in front of the Greenwich house in a photograph that dates from the early 1890s (fig. 3). Five more children were born during the course of the Greenwich years: Eric Christian, in 1890; Quentin, in 1892; Violet, in 1895; and Godfrey, in 1897. Eric Christian, however, lived only a year, and Elsie died in 1895 at age nine. Her death was an especially great loss to her father. At the time of Elsie's death, Twachtman's friend and colleague Theodore Robinson wrote to Harrison Morris, Secretary and Managing Director of the Pennsylvania Academy, that "Poor Twachtman has had an awful time—Scarlet fever in his family—his little Elsie, 8 [sic] years old, died Saturday and was buried Mon. a.m. Weir was at the funeral, the only one I believe. T. is now with his family and it will be some time before they are out of all danger."[5]

During the early 1890s, Twachtman created a number of pastels depicting his children, rendered in a soft and sketchy technique. Like James McNeill Whistler, he used toned paper and incorporated the paper's color into the work's design. His rendering of Marjorie and Elsie, both wearing large hats, was given special notice when it was shown in Twachtman's one-man exhibition in 1891 at the Wunderlich Gallery, New York (fig. 27). One reviewer commented that "A sketch of two little girls, 'Marjorie and Elsie,' had qualities of style which we should hardly know where else to look for in an American painter."[6] Other pastel portraits demonstrate that Twachtman was quite adept at delineating a figure's features (fig. 28). Although his pastel figural renderings are not as detailed or elegant as those of his friend Thomas Dewing, they demonstrate a similar minimal execution combined with a refined and poetic expression.

But the figure paintings created during Twachtman's Greenwich years depart from realism and from the modes of portraiture fashionable in the late nineteenth century. The figures are not posed in bare rooms illuminated from side windows, as in the works of painters of the Boston School such as Edmund Tarbell and Frank W. Benson. Instead, Twachtman chose to depict his subjects out of doors and in the sunlight, and often placed against or in the midst of the garden that Twachtman created (probably along with his wife). The house,

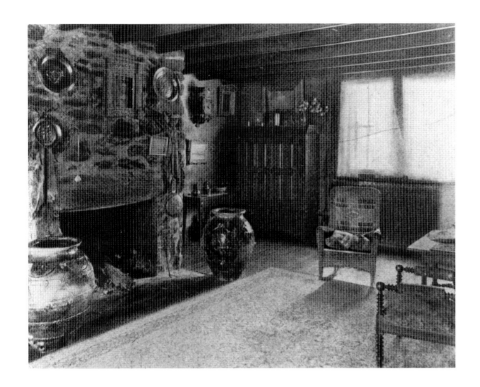

fig. 26
Interior of Twachtman's house on Round Hill Road, Greenwich, ca. 1902–1905. Photograph. From Goodwin, "An Artist's Unspoiled Country Home," p. 629. Courtesy of The New York Public Library.

which was expanded over the years to accommodate the growing family, is also shown in the background of a few of the figural works.

The unconventional manner in which Twachtman depicts his subject's features is one of the more striking aspects of his figural style. There is no more detailing in the subjects' faces than in the flowers and shrubs in the garden. Although the generalizing of features appears casual and perhaps even unfeeling, Twachtman, as a landscapist, instinctively followed his aesthetic need for consistency, for an equal surface treatment throughout his canvases. In fact, the decision to unite figures and landscape may have been one Twachtman had considered for some time. During his French period, he was one of the few artists of his day to be critical of the works of Jules Bastien-Lepage, the French painter of peasants who depicted highly finished figures set in landscapes filled with detail and rendered in a loose, painterly style. In 1885, Twachtman wrote to Weir, expressing his reactions to the large memorial exhibition of Bastien-Lepage's work then being held in Paris: "All the younger men are mad on B. LePage and say that he is the greatest of modern masters and compare him to Holbein, a thing that I cannot understand. . . . [H]e was always small and fussy and never looked for the value of a large mass for the whole."[7]

Twachtman's treatment of the figure is perhaps the closest to that of the French Impressionist Claude Monet, who also painted his family with the same brushwork and color as the landscape. There is no evidence that Twachtman saw Monet's work in France, but it is likely that he would have seen the exhibition of works by Monet held at the Union League Club in New York in 1891, or possibly the show of works by Monet, Pissarro, and Sisley held at

fig. 27
John Henry Twachtman, *Two Children (Marjorie and Elsie)*, ca. 1891. Pastel on cardboard, 23½ × 14½ in. (59.7 × 36.8 cm.). Private Collection.

fig. 28
John Henry Twachtman, *Study of a Head*,
ca. early 1890s. Pastel on paper, 12 × 10 in.
(30.5 × 25.4 cm.). The Brooklyn Museum,
New York, Museum Collection Fund.

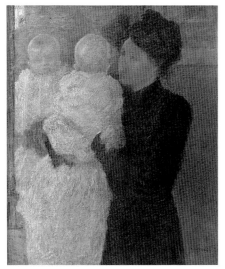

fig. 29
John Henry Twachtman, *Mother and Child*,
ca. mid-1890s. Oil on canvas, 30⅛ × 25⅛ in.
(76.5 × 63.8 cm.). The Fine Arts Museums
of San Francisco, Jacob Stern Family Loan
Collection.

J. Eastman Chase's Gallery in Boston in 1891 (Twachtman had two one-man shows at Chase's gallery during 1885 and 1886).[8] He also gained familiarity with French Impressionism through Theodore Robinson, who spent several several years in Giverny, where he absorbed Monet's style. From 1892 until his death in 1896, Robinson was extremely close to Twachtman. Twachtman most fully assumed the title of "Impressionist" in 1893, when he had a joint exhibition with J. Alden Weir at the American Art Galleries in New York, held in conjunction with a two-man show of the works of Monet and Paul Albert Besnard held in the same gallery. However, as the critic for the *New York Sun* noted: "While like Monet, [Twachtman and Weir] have striven toward the expression of Impressions of landscape and figure, they have looked with soberer eyes. There is none of the splendid, barbaric color that distinguishes the works of the Frenchman [Monet]. They tend to silvery grays modified by greens and blues quite as silvery."[9] In general, Impressionism influenced Twachtman to the extent that it lightened his palette and sharpened his eye for truth in nature's colors. But he was never enslaved by the Impressionists' brush handling, and a careful study of his canvases reveals that he did not hesitate to make changes in nature's colors whenever it was aesthetically desirable. He was less concerned with optical effects in nature than with creating works expressive of his moods and reactions to nature and made constant changes to improve compositions, frequently altering the size and location of objects in the landscape.

While Twachtman's full adherence to Impressionism may be debated, his commitment to landscape was complete. Indeed, Twachtman's landscape sensibility and approach is crucial to the understanding of his Greenwich figure paintings. In paintings of figures out of doors, his subjects are treated as part of the landscape, rather than as posed in a landscape. Paintings such as *In the Sunlight* (pl. 9) and *On the Terrace* (pl. 11) would obviously fail without the figures' presence. This is particularly the case with *On the Terrace*, in which the group composed of Martha Twachtman holding an infant and flanked by two children is as much a part of the total design as the "V" formed by the flower hedge line and the secondary "V" formed by the hedge line and the roof of the house.

In a simpler composition, for example, *In the Sunlight*, the single figure dominates the landscape for no other reason than the fact that it is the central form in the composition and the largest. Even the sunlit flat area is almost as important and enhances the whole rather than being there only to set off the portrait. In the related painting *Figure in Sunlight* (pl. 10), the artist's wife is again the dominant form. Even though seated on a shaded porch, her figure is given the same generalized treatment as the stone structure behind her and assumes the contours of an architectural form in the landscape. In comparison to paintings such as Eastman Johnson's *Hollyhocks* (New Britain Museum of American Art, New Britain, Connecticut) and other depictions of women in gardens by Frederick Carl Frieseke, Philip Leslie Hale, Childe Hassam, or Robert Reid, which associate the pleasures of a garden's blooms and nature's

freshness with the female figure, Twachtman's works treat the figure as a formal motif in the landscape. They are to a great extent devoid of the gentility that exudes from so many works by American artists of the period.

Among Twachtman's figure paintings—more aptly called landscapes-with-figures—there are exceptions. One of these is *Mother and Child* (pl. 12), which comes closer to being a portrait in the conventional sense. The depictions of Martha and Violet are clearly rendered and Twachtman may have sought to invest the portrait with personal feeling, conveying the angelic qualities of his third daughter, born in the same year in which her older sister Elsie died. Yet, his interest in composing the figure in the landscape is still apparent as the triangular arrangement of the figures is balanced by the receding triangle created by the house, shown foreshortened behind the figures.

In Twachtman's only known interior painting of figures created during the Greenwich years, also called *Mother and Child* (fig. 29), the overall composition is again the predominant aesthetic aspect of the work. Twachtman's awareness of French Impressionist painting is strongly indicated by his inclusion of a mirror in the painting, a motif which appears in works by Edouard Manet and Edgar Degas and many other French and American painters in the era. A contemporary painting by J. Alden Weir, *Face Reflected in a Mirror* (fig. 30), is very similar to Twachtman's *Mother and Child* and suggests that the two shared ideas about figure painting in the 1890s, although their technical methods differed vastly during the decade. In both paintings, the figures are shown in front of a mirror, which provides a different angle on their forms and implies the room in front of them. Both works suggest the influence of James McNeill Whistler in the asymmetrical balance of formal elements, the inclusion of figures as parts of arrangements, and the restricted tonal palettes. Weir's composition is, however, more complex and more carefully worked out than Twachtman's and shows the continued impact of his academic background. Weir trained in Paris at the Ecole des Beaux-Arts under Jean-Léon Gérôme, who stressed the execution of preliminary studies for finished works and the careful positioning of the figure in a well-defined space. But the balancing of horizontal and vertical elements in the painting and the cropping of the figure (by the bedpost that appears behind her in the mirror) indicates Weir's interest in Japanese art and demonstrates the modern direction of his work of the 1890s.

In comparison to Weir's depiction, Twachtman treats figures more ab-stractly, showing them broadly in the forefront of the canvas and repeating the group in reverse direction in the mirrored reflection. He expresses effects of light and atmosphere in the room through a thick, layered brushstroke tech-nique that brings out the stark whiteness of the baby's dress next to the dark navy of Martha's and repeats these tones in softer variations in the mirror's reflection. The mirror takes up a larger area of the room in Twachtman's painting than in Weir's and sets the general atmospheric tone of the space. Even though the painting depicts a domestic interior scene, the artist's interests are the same as those taken up in paintings of nature—reflections of light, color

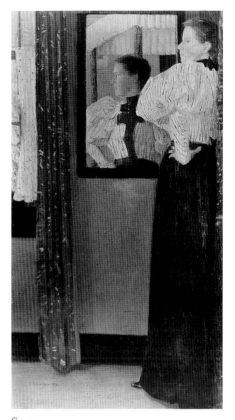

fig. 30
J. Alden Weir, *Face Reflected in a Mirror*, 1896. Oil on canvas, 24¼ × 13⅜ in. (61.6 × 34.6 cm.). Museum of Art, Rhode Island School of Design, Providence, Jesse H. Metcalf Fund.

gradations, and surface textures. Twachtman seems to have considered *Mother and Child* to be one of his most successful works, since he included it as one of six paintings in the first exhibition of the Ten American Painters in 1898 (under the title *Baby's Reflection*). He also exhibited the work at the Pennsylvania Academy Annual in 1899, in his 1901 one-man exhibitions in Chicago and Cincinnati, and in the Pan-American exhibition, also held in 1901. When the painting was exhibited in 1898, the *New York Sun* reviewer noted that "The broad truth of form is given in the picture called 'Baby's Reflection' (No. 37), but with it is the added charm of light and color. Why not? A picture that fails to please the eye will have hard work reaching the mind or emotions."[10] When the painting was shown at the Albright Art Gallery in 1913, a critic noted that "Mother and Child . . . one of the rare figure paintings, the mother holding the baby in her arms, the face of the child reflected in a mirror, has an unusually fine disposition of masses; the child's head is beautifully drawn, the helplessness of the small body subtly expressed."[11]

As these reviews indicate, despite the abstract qualities of Twachtman's figural renderings, their sensitive personal nature remained a vital aspect. It was the artist's family that occasioned his return to figural rendering, and the paintings express his feelings for his wife and children. Twachtman's paintings of the figure are unique in their day for their blending of the human with the abstract, the personal experience of his family in the sunlight and in the garden joined with the conveyance of atmosphere and outdoor light. Eliot Clark's 1924 discussion of the figure paintings sums up their contribution: "The canvases which best represent Twachtman in [the figural] genre date from the Greenwich period, and are for the most part pictures of his immediate family. Not portrait studies or physiognomical characterizations, the figure is seen as a whole, and the painter finds his interest more in the attitude and suggested environment than in detailed delineation and likeness. He is interested particularly in the luminous envelopment of the figure and in the study of local color as modified by the dominant hue of the light."[12]

Footnotes

1 Alfred Henry Goodwin, "An Artist's Unspoiled Country Home," *Country Life in America* 8 (October 1905): 629.

2 J[ohn] H. Twachtman, [Paris], to [J. Alden] Weir, [Branchville, Conn.], [winter 1883 or 1884], Weir Family Papers, MSS 41, Harold B. Lee Library, Archives and Manuscripts, Brigham Young University, Provo, Utah.

3 S[tanford] W[hite], [Paris], 3 May 1884, to [J. Alden] Weir, [Branchville, Conn.], Weir Family Papers.

4 "An Art School at Cos Cob," *Art Interchange* 43 (September 1899): 56–57.

5 Th[eodore] Robinson to Harrison Morris, 17 January 1895, Archives, Pennsylvania Academy of the Fine Arts, Philadelphia.

6 "My Notebook," *Art Amateur* 24 (April 1891): 16.

7 J[ohn] H. Twachtman, Paris, to [J. Alden] Weir, [Branchville, Conn.] 6 April 1885, Weir Family Papers.

8 *Exhibition of Paintings by Old Masters, and Modern Foreign and American Artists, together with an Exhibition of the work of Monet the Impressionist*, exh. cat. (New York: Union League Club, 1891); *The Impressionists of Paris: Claude Monet, Camille Pissarro, Alfred Sisley*, exh. cat. (Boston: J. Eastman Chase's Gallery, 1891); *Paintings by J. H. Twachtman*, exh. cat. (Boston: J. Eastman Chase's Gallery, 1885); Paintings and Pastels by J. H. Twachtman, exh. cat. (Boston: J. Eastman Chase's Gallery, 1886).

9 "A Group of Impressionists," *New York Sun*, 5 May 1893, p. 6.

10 J.C.V.D. [John Charles Van Dyke], "Ten American Painters," *New York Evening Post*, 1 April 1898, p. 7.

11 "Memorial Exhibition of the Works of John H. Twachtman," *Albright Academy Notes* (Buffalo) 8 (April 1913): 66.

12 Eliot Clark, *John Twachtman* (New York: Privately Printed, 1924), p. 54.

John H. Twachtman's Mastery of Method

by Richard J. Boyle

"He . . . does not elaborate and insist too much on his picture"
New York Times, 1890[1]

"Eyes open, I listen to spring in the four directions"
Tan Taigi (1709-1771)[2]

Like his canvases *Meadow Flowers* (pl. 1) and *Tiger Lilies* (pl. 3), *Wildflowers* (pl. 2) was painted from an unusual point of view. In its densely orchestrated brushwork, emphasis on surface texture, and especially in its almost telescopic use of the close-up, *Wildflowers* is a striking example of Thomas Dewing's remark that Twachtman "never composed or arranged in the conventional sense."[3]

John Twachtman was the kind of artist who responded in varying ways to his subject—primarily aspects of landscape—depending on the idea, or a mood and feeling suggested by that subject and the circumstances under which he worked. During his Greenwich period, from 1889 to about 1900, he painted in the country, "at all seasons of the year," applying a conservative Impressionism modified by his own very personal outlook.[4] In the winter he painted the snow he liked so much with an enveloping impasto, seemingly as thick as the snow itself; conversely, thick paint and tightly knit handling also conveyed the lush feel of summer. In the fall and spring he opened the space and allowed more air into his pictures, appropriate to the change and movement of those seasons; and in his response to spring he seemed to paint with all of the delicacy of his work in pastel—or that of the Japanese art he so admired. And even though his oils *Tiger Lilies, Wildflowers* and *Meadow Flowers* share a common framework provided by the low angle of the scene, immersing and surrounding the viewer who is then at one with this aspect of nature, each of these paintings is very different in hue, tone, and touch.

The treatment of the flowers in *Tiger Lilies* is more specific and is set off against a lower tonal scale and a steeper angle of vision than that of *Wildflowers* or *Meadow Flowers. Wildflowers* is more broadly painted and generalized, done in a middle-value range and with less of the horizon visible; and *Meadow Flowers* has no horizon, has a higher value scale, brighter color, and a more delicate, even fragile, overall pattern. Twachtman's success in realizing his ideas and imbuing each of these paintings with a distinct and individual presence is

fig. 31
John Henry Twachtman, *Meadow Flowers* (detail of pl. 1).

not only a tribute to his intelligence and powers of imagination, but argues a command of his materials and a mastery of method as well.

It can also be argued that Impressionism itself is a method rather than a style, a technique as representative of the nineteenth century's accelerating changes in technology and swifter pace of life as of the effort to capture the evanescent effects of the natural world. It is not a style in the sense that the Baroque, Rococo or Neo-Classicism are styles; nor is it a style in the sense that the officially accepted academic painting of the day was a style. Style, for the Impressionists and their adherents, including American painters, was a matter of the artist's personal handwriting, rather than that of a school or the stylistic policy of a movement. Yet, despite differences in the result and general outlook between the academic and avant-garde painter, both shared in a concern for technique; mastery of technique was an important part of every European artist's training.[5] And training, the right training, was the principal reason that Twachtman and his colleagues in the 1870s and 1880s mounted what was in effect an invasion of Europe, particularly France, in pursuit of technique. It was a pursuit that fit the American artists' interest in "the how" of what they did, and it had such a technically successful outcome that it was remarked upon by European critics. "What is striking in all American pictures," wrote Richard Muther in his *History of Modern Painting*, "is their eminent technical ability. There is in these pictures a strenuous discipline of talent."[6] Although Twachtman was perhaps the most personal and poetic painter among his colleagues, and although even then he had a leaning toward abstraction (he once remarked that the work of the influential Bastien-Lepage consisted "too much in the representation of things"[7]), and despite the fact that he was more of an "internal" artist than, say, Theodore Robinson, Willard Metcalf, or Childe Hassam, he was no exception to the rigors of the technical training then in vogue. In fact, he attended four art schools, full- and part-time, here and in Europe, for about twelve years; and that does not include the exchange of ideas with his fellow artists after he returned to the United States in 1886.

Yet even an artist as internally driven as Twachtman would have been subject to external forces—his environment, for example, and technology. The nineteenth century saw an explosion of technology; some of which, such as improvements in paper making, the invention of the collapsible tin tube for oil colors, improvements in the portable paint box and easel—enabling the painter to work outdoors for long periods of time—were of direct influence on the artist. Of even more direct use were the products of the fledgling chemical industry. From the beginning of the nineteenth century on, the discovery of new pigments so transformed the artist's palette that painting has not been the same since. Twachtman's palette, for example, consisted of pigments almost entirely invented in the nineteenth century. In an interview with the artist's son, John Douglass Hale found that Twachtman used ultramarine blue, rose madder, and the cadmium yellows; and in *Wildflowers* and *Tiger Lilies*, it looks as though cadmium orange and perhaps viridian were used as well.[8] Madder, although

long in use as a dye, was made into an artist's pigment in 1826; artificial ultramarine (French ultramarine), the substitute for the natural variety made from costly lapus lazuli, was introduced in France, also in 1826; the cadmium colors were developed in the 1840s, and were definitely in use by 1851; and viridian green was in artists' hands by 1862. The only color on Twachtman's palette in use before the nineteenth century was white; and he very probably used flake (lead) white, which has great covering power and was the only white widely available to artists until the middle of the century. Even after that it remained the white of preference until the early twentieth century.[9]

Following the invention of the daguerreotype and its public demonstration in 1839, photography became an ever increasing and ever widespread technology that had an enormous influence on painting and drawing. There is no evidence that Twachtman ever used the camera or had been significantly influenced by it, yet the point of view in both *Tiger Lilies* and *Wildflowers* is not a natural one—in other words, it was a view he could not have seen unless he were lying on his stomach to paint it; and it is a view that is reminiscent of a photographic close-up, or one seen through a telescopic or binocular lens. Further, although he used this viewpoint in connection with several of his paintings of Horseneck Falls, the little waterfall on his property in Greenwich, it seems to be one he preferred for many of his flower subjects. Twachtman would have been aware of photography, even before George Eastman made the camera popular and ubiquitous with his invention of the Kodak in 1888. Works of art had been reproduced photographically since about mid-century, and the use of the close-up was a special feature of archaeological and architectural photography, with their emphasis on building details, of inscriptions and even manuscripts, all of which required sophisticated camera angles.[10] Whether or not the camera influenced Twachtman is a matter of speculation, of course, but what is

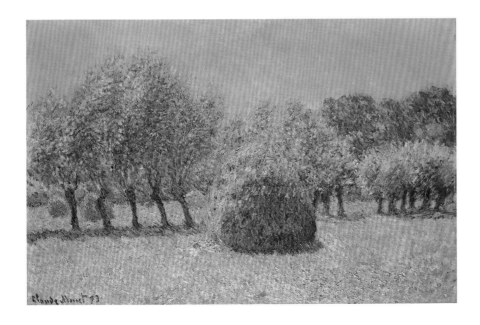

fig. 32
Claude Monet, *Haystack*, 1893. Oil on canvas, 26 × 40 in. (66 × 101.6 cm.). Museum of Fine Arts, Springfield, Massachusetts, James Philip Gray Collection.

fig. 33
John Henry Twachtman, *Wildflowers* (detail of pl. 2).

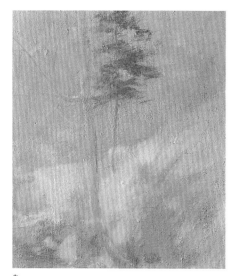

fig. 34
John Henry Twachtman, *Winter Harmony* (detail), ca. early 1890s. Oil on canvas, 25¾ × 32 in. (65.4 × 81.3 cm.). National Gallery of Art, Washington, D.C., Gift of the Avalon Foundation.

not purely speculative are the indirect benefits of advances in transportation technology. Improved steamship and train travel, with a corresponding lowering of fares, not only enabled Twachtman and his contemporaries to travel abroad to study, but also enabled them to establish artist colonies, both here and in Europe, in places that were paintable, accessible, and cheap. Gloucester, Greenwich, and Cos Cob were all accessible because of the train; and conversely, the metropolitan centers—New York, Boston, and Philadelphia, with all their resources—were equally easy to get to. And when both Twachtman and his friend J. Alden Weir settled permanently in Connecticut, in Greenwich and Branchville, respectively, they were within easy commuting distance of New York City.

It was after 1889, when Twachtman had settled on his seventeen-acre farm on Round Hill Road in Greenwich, that his subject, technique, and style began to come together. He had found an environment, a place that suited him perfectly and one that would prove to be a never-ending source of inspiration and motifs. It was a time when he developed both that modified approach to Impressionism for which he became famous and his personal and poetic point of view. The farm on Round Hill Road was, in a sense, Twachtman's Giverny, and Monet was the ultimate source for his modified Impressionism. For Twachtman and most of his contemporaries, with the exception of Mary Cassatt, who sat at the feet of Degas, Claude Monet was the model for the American practitioners of the Impressionist method. Although Twachtman's sense of abstraction and feeling for paint surface put him close to Monet's work, there are important

differences, as a comparison between the handling and color of Monet's *Haystack* of 1893 (fig. 32) and that of Twachtman's *Wildflowers* (fig. 33) indicates. Monet's technique in this picture is complex and detached and based on intensity of hue; there appear to be several types of brushstrokes serving different areas of the painting for lights, highlights, shadow, and overall texture, resulting in a build-up of pigment and a dynamic interchange among the various hues. The strongest saturation of color lies in the horizontal shadow created by the trees, an area where hot direct sunlight would not, in fact, "bleach" the color. The overall effect is one of seeming objectivity. Twachtman, on the other hand, is more involved with the subject from the start; his brushwork tends to be more descriptive than Monet's and more romantic. It is less precise and *seemingly* less controlled, and the strongest and most saturated color serves to focus on his subject, despite the abstract quality. And rather than dealing with hue against hue, as in Monet, Twachtman has retained a value system of lights and darks which tends to create mood; the result is a sense of subjectivity. And, as in Monet's work, if there is such a thing as painting about painting, Twachtman includes a statement about nature itself, rather than solely about the nature of painting.

During this period, Twachtman consciously began to develop a "dry" look to his painting. Disliking oily pigment and a shiny surface, he began to use mastic varnish cut with turpentine as a painting medium, which gave him more of a "dragging" brushstroke similar to dry brush in watercolor. And he often liked to build up his canvases with heavy paint and bring out such details as tree branches and flowers with a deft and delicate brush, scumbling or glazing over his dry impasto, as in the detail of the tree in *Winter Harmony* (fig. 34), or the details of flowers in the Brooklyn Museum's painting *Meadow Flowers* (fig. 35).[11] Another important contributing factor to Twachtman's oil painting technique at this time was his work in the fragile and often difficult medium of pastel. His reputation as a master of pastel dates from about 1888, with the pictures he submitted to the second exhibition of the Society of Painters in Pastel. In fact, his work in this medium made at least one critic sit up and take notice: "One of the pastels, *Grey Venice*, hardly yields to the best of Whistler," wrote the critic of the *New York Times*, "and is better than many of the latter's. Here the perspective is fine, the drawing tender, the pink on the walls and roofs brilliant, yet of the utmost delicacy."[12] And in the review of the Society's 1890 exhibition, the same critic made Twachtman's technical mastery the centerpiece of his essay. "Pastel," he wrote, "is a treacherous material, because it looks so easy and at once gives very . . . tangible returns to the person who uses it. There is no sinking in or unexpected change of colors. . . .But to handle the chalks with mastery requires a special training that many . . . excellent artists do not or can not undergo. . . . not one appears to have hit the right method of using pastels better than Mr. J. H. Twachtman. He . . . does not elaborate and insist too much on his picture. He leaves the ground a good deal bare, and sketches, rather than draws an elaborate picture."[13]

fig. 35
John Henry Twachtman, *Meadow Flowers* (detail of pl. 1).

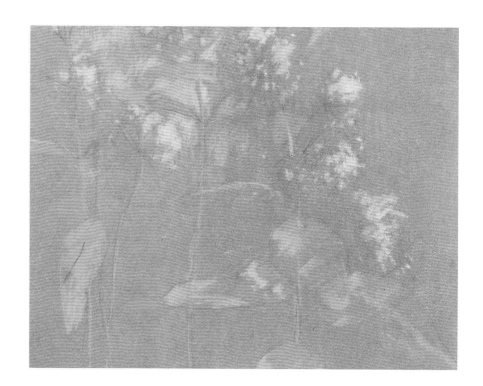

fig. 36
John Henry Twachtman, *Wildflowers*
(detail of pl. 17).

fig. 37
James McNeill Whistler, *Winter Evening*,
1880. Pastel on brown paper, 11¾ × 8 in.
(29.8 × 20.3 cm.). Freer Gallery of Art,
Smithsonian Institution, Washington, D.C.

The pastel medium provides a link between drawing and painting, and the word itself comes from the Italian *pastello*, which in turn derives from *pasta* or paste. The manufacture of pastels is simple, requiring powdered pigment and minute quantities of binder—usually gum tragacanth—in order to hold the pigment together sufficiently to form sticks or crayons. And because there is a limit to the variety of tones that can be obtained by applying colors on top of each other, or mixing them by rubbing the surface, pastel requires a greater range of tones—about sixty to eighty—than do other painting techniques. Therefore, in addition to the full tone, each hue comes in several half-tones mixed with white, the best grades of which have been thoroughly precipitated (calcium carbonate in its whitest and purest form is usually called precipitated chalk).[14] In regard to its use, Kurt Wehlte makes a distinction between "pastel drawings executed in directly applied strokes and pastel painting in which the colors are blended on the surface."[15]

As indicated in the details of *Wildflowers* (fig. 36), *Weeds and Flowers* (pl. 16), and *Trees in a Nursery* (pl. 18), Twachtman approached pastel as a drawing medium. Over a sketchy preliminary drawing done on toned paper in charcoal or pencil, he executed a completely free kind of drawing, one done with great economy of means and "not smudged, but etched. . . .The paper was not to be a Nubian battlefield."[16] This economy of means, in which Twachtman does not "insist too much on his picture," is a mark of Oriental art and it is very much the method of James McNeill Whistler.

After languishing since the end of the eighteenth century, the art of pastel enjoyed a revival of interest toward the end of the nineteenth. Jean François

Millet, Giuseppe de Nittis, and especially Edgar Degas—who made of it a complex, innovative, and important medium—were responsible for its revival among European artists. But for John Twachtman and his fellow members of the Society of Painters in Pastel, it was Whistler who was the most influential figure.[17] Twachtman's pastel technique relates to his sojourn in Venice, and Whistler's influence on American painters in the approach to both etching and pastel also dates from that time. The spare, "less is more" method of Whistler's Venetian work—the very opposite of that of Degas—was novel (fig. 37); and it was based on a vision that seemed to be in accord with Twachtman's own. Twachtman was in Venice from 1877 to 1878. In early October 1880 he returned to Italy, joining Frank Duveneck's school in Florence in November, where he remained until the spring of 1881. He was in Venice briefly at the end of 1881, and again at the end of 1885. Whistler arrived in Venice in mid-September 1879, remaining until mid-November 1880; and when he returned to London, it was with a substantial body of work, including a considerable number of pastels. He and Twachtman appear to have missed each other in Venice, unless they met when Twachtman returned to Italy in early October 1880, but that is unlikely. Nevertheless, there is no question about the similarity of pastel technique between the two artists (figs. 38, 39); and Twachtman would have certainly heard about Whistler's work from Duveneck's coterie, the "Duveneck Boys," with whom the older artist lived for part of the time he was in Venice. Then again, despite the fact that Whistler never came back to Italy, his spirit seemed to linger and there were always plenty of Whistler stories circulating around artist's hangouts such as Florian's. "I heard far more of the few little inches of Whistler's

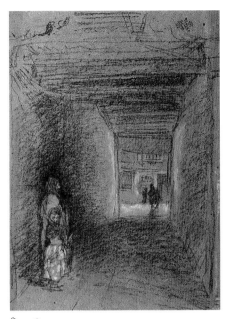

fig. 38
James McNeill Whistler, *The Beggars–Winter*, ca. 1880. Pastel on brown paper, 11¾ × 8 in. (29.8 × 20.3 cm.). Freer Gallery of Art, Smithsonian Institution, Washington, D.C.

fig. 39
John Henry Twachtman, *Unfinished Interior Perspective Study* [which is the verso of *Study of a Landscape*]. Pastel on paper, 14⅛ × 21¼ in. (35.9 × 54 cm.). The Brooklyn Museum, New York, Museum Collection Fund.

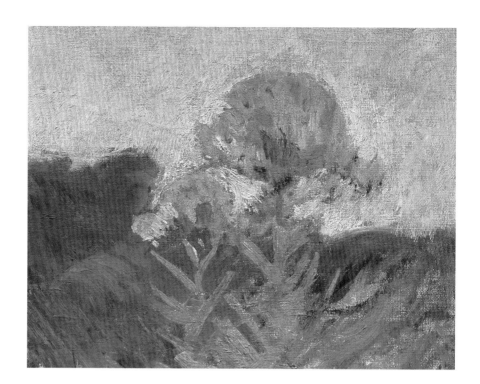

fig. 40
John Henry Twachtman, *Wildflowers* (detail of pl. 2).

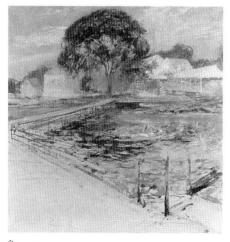

fig. 41
John Henry Twachtman, *Harbor View Hotel*, ca. 1902. Oil on canvas, 30 × 30 in. (76.2 × 76.2 cm.). The Nelson-Atkins Museum of Art, Kansas City, Missouri, Nelson Fund.

etchings and of Whistler's pastels," wrote Elizabeth Robbins Pennell, "than of the great expanse of Tintoretto's Paradise talk could not be kept long from Whistler."[18]

In addition to the suitability of the pastel medium to Twachtman's temperament and, indeed, as the near perfect expression of aspects of his subject matter, his use of the medium very probably influenced his technique in oil, especially during his Greenwich period, when the important influences on his art, technical and otherwise, were absorbed and transformed by his personal point of view and poetic vision. Pastel certainly has the "dry" look for which Twachtman was searching; its purity and brightness of color could very well have had an effect on the lightening of his palette at this time; and the delicacy of touch required of pastel could have been transferred to such paintings as the Brooklyn Museum's *Meadow Flowers* (figs. 31, 35). Moreover, Twachtman's practice of staining canvases with a thin tone of modified yellow ocher, which dates from this period, could have also been transferred from the habit of working with pastel on toned papers of brown or gray. According to the artist's son, who helped his father prepare his canvases, the use of toned grounds was very much the rule, and he could not remember Twachtman painting on a white ground.[19] Evidence of this practice can be seen in the detail of the upper right of the oil *Wildflowers*, and in his last and unfinished painting, *Harbor View Hotel* (figs. 40, 41).

Like *Harbor View Hotel*, with its full conceptual realization apparent even in its incomplete state, *Tiger Lilies* and *Wildflowers* demonstrate that at this point Twachtman's subject, idea, technique, and style had become one and the

same. In his search for the right technique, he had absorbed his influences, technical and philosophical—Duveneck, Whistler, Monet, Japanese art—and had transformed and modified them through an absorption in his environment and the force of his personality. He eschewed the objectivity of Monet and opted instead for an unconventional point of view of nature analagous to nature itself. It was a point of view he shared with the Japanese, or even that of a Chinese painter of the Sung period, in poetic subjectivity and closeness to nature (fig. 42). The flower studies are superb examples of his attitude toward nature. It was an almost mystic closeness, which, when allied to his mastery of method, truly yielded a unique and poetic insight; as though Twachtman had indeed listened "to spring in the four directions."

fig. 42
Ma Yuan, *Bare Willows and Distant Mountains*, ca. 1200. Ink and colors on silk, 9½ × 9½ in. (24.1 × 24.1 cm.). Museum of Fine Arts, Boston, Special Chinese and Japanese Fund.

Footnotes

1 "Society of Painters in Pastel," *New York Times*, 5 May 1890, p. 4.

2 Tan Taigi, *From the Country of Eight Islands: An Anthology of Japanese Poetry*, edited and translated by Hiroaki Sato and Burton Watson (New York: Columbia University Press, 1986), p. 335.

3 Thomas Dewing, "John Twachtman: An Estimation," *North American Review* 176 (April 1903): 554.

4 [John H.] Twachtman, Greenwich, [Conn.], to [J. Alden] Weir, [Branchville, Conn.], 16 December 1891, Weir Family Papers, MSS 41, Harold B. Lee Library, Archives and Manuscripts, Brigham Young University, Provo, Utah.

5 See Albert Boime, *The Academy and French Painting in the Nineteenth Century* (New Haven: Yale University Press, 1971).

6 Richard Muther, *History of Modern Painting*, vol. 3 (New York: Macmillan and Co., 1906), p. 480.

7 J[ohn] H. Twachtman, Paris, to [J. Alden] Weir, [New York], 2 January 1885, Weir Family Papers, MSS 41, Harold B. Lee Library, Archives and Manuscripts, Brigham Young University, Provo, Utah.

8 John Douglass Hale, *The Life and Creative Development of John H. Twachtman*, 2 vols., Ph.D. dissertation, Ohio State University, Columbus, 1957 (Ann Arbor: University Microfilms International, 1958), p. 215.

9 On the introduction of artist's pigments in relation to Impressionism, see Richard J. Boyle, *American Impressionism* (Boston: New York Graphic Society, 1974), pp. 25–27. Additional valuable information was also received in a letter of 6 May 1974 from the late Ralph Mayer to the author.

10 See John L. Fell, *Film and Narrative Tradition* (Norman, Okla.: University of Oklahoma Press, 1974), p. 62.

11 On Twachtman's "dry" painting, see Hale, *Life and Creative Development of John H. Twachtman*, pp. 232, 242, 248; on mastic varnish, see Max Doerner, *The Materials of the Artist and Their Use in Painting* (New York: Harcourt, Brace and Company, 1934), pp. 130-131; Kurt Wehlte, *The Materials and Techniques of Painting* (New York: Van Nostrand, Reinhold Co., 1975), pp. 397-398. Because of his use of mastic as a painting medium, as well as his liking for a dry surface, Twachtman probably did not apply a final, or finishing, varnish to his paintings.

12 "Society of Painters in Pastel," p. 4.

13 "Society of Painters in Pastel," p. 4.

14 Ralph Mayer, *The Artist's Handbook of Materials and Techniques* (London: Faber and Faber, 1951), p. 46.

15 Wehlte, *The Materials and Techniques of Painting*, p. 464.

16 Hale, *Life and Creative Development of John H. Twachtman*, p. 248.

17 See Dianne H. Pilgrim, "The Revival of Pastels in Nineteenth-Century America: The Society of Painters in Pastel," *American Art Journal* 10 (November 1978): 43–62.

18 Elizabeth Robbins Pennell, *Nights* (Philadelphia: Lippincott, 1916), pp. 94-95.

19 Hale, *The Life and Creative Development of John H. Twachtman*, p. 213.

Foreword to the Catalogue

The works included in the catalogue are organized in three groups: floral paintings, figural paintings, and floral pastels. Since Twachtman did not date his works during his Greenwich years, the dates listed in entries have been given in approximate terms, determined by stylistic traits and exhibition records. The dates provided are not definitive and adjustments may be made in the Twachtman catalogue raisonné, or as additional information comes to light. Within each group, works are presented in a general chronological order with the exception of *Flowers* (pl. 8), a still life which follows Twachtman's paintings of outdoor floral subjects.

For documentation, I have again relied to a great extent upon John Douglass Hale's important Ph.D. dissertation of 1957, *The Life and Creative Development of John H. Twachtman*, which includes a critical discussion of Twachtman's career and works as well as a catalogue of his located and unlocated works, the former listed in Catalogue A, the latter provided in a general catalogue. For all paintings and pastels in this exhibition included in Hale's catalogue, cross-references are provided. When works are discussed or illustrated in Hale's text, these citations are given in the References section.

For provenance listings, galleries, dealers, and auction houses are indicated by parentheses to distinguish them from private owners. Exhibitions and References, the two sections that follow in each entry, provide information in abbreviated form. Exhibition listings include catalogue numbers when they exist. Reference listings indicate locations in which works are discussed and/or illustrated by page, unless a source is unpaginated or has another system of numbering.

Full citations appear in the index that begins on page 97. Exhibitions are listed chronologically; references are in alphabetical order by author. When no author is given, references are abbreviated according to the title of the publication.

L.N.P.

Plate 1

Meadow Flowers, ca. early 1890s

Oil on canvas
33 × 22 in. (83.8 × 55.9 cm.)
Signed lower left: *J. H. Twachtman*
The Brooklyn Museum, New York,
 Caroline H. Polhemus Fund, 13.36

Twachtman treats flowers as integral with the landscape setting in this painting and other floral depictions rendered during the Greenwich years. In *Meadow Flowers*, blossoms take up the entire pictorial field, however, and references to the surrounding site are omitted. The painting is simplified in all ways, so that the focus is on the flowers themselves and the sensations they impart. Even the background, painted in layers of light green over dark blue, suggests air and atmosphere rather than earth or sky. Twachtman enhances the immediacy of the experience of the subject through the close-up vantage point, which thrusts the viewer into the midst of the windblown blossoms.

For *Meadow Flowers*, Twachtman transferred the aesthetic he had developed for pastels of flowers in the late 1880s and early 1890s (see pls. 15–20) to paint and canvas. The lightly colored background, comparable to the toned papers he used for pastels, envelops the blossoms and at the same time allows their more delicate aspects to emerge from its depths. Using a loaded brush, he conveys the impact of light reflecting on blowing petals. As William Gerdts points out in his essay in this catalogue, this painting may be *Golden Rod and Wild Aster*, a work included in the May 1893 exhibition at the American Art Galleries in New York that Twachtman shared with J. Alden Weir, while a show of works by Claude Monet and Paul Albert Besnard was held concurrently in the same venue. The resemblance to Twachtman's pastels, the controlled brushwork, the litheness of the floral forms, and the interest in flowers of the field suggest that *Meadow Flowers* dates from the early 1890s.

HALE: cat. A no. 177, p. 549.

PROVENANCE: Martha Scudder Twachtman (the artist's wife), Greenwich, Connecticut; to William T. Evans, Montclair, New Jersey, by 1908; (American Art Association, *Sale of the Collection of William T. Evans*, 31 March–1, 2 April 1913, no. 135); to present coll., 1913.

EXHIBITIONS: 1915 Panama-Pacific, no. 4074; 1932 Brooklyn Museum, no. 113a; 1939 Munson-Williams-Proctor, no. 16; 1960 Brooklyn Museum, no. 208; 1973 National Gallery, no. 62; 1977 Whitney Museum; 1980 Henry Art Gallery (pp. 139, 67 col. ill.); 1983 Montclair Art Museum (pp. 80, 138, 112 ill.); 1984 Whitney Museum (pp. 62, 126–127, 144 col. ill.).

REFERENCES: Baur 1936, p. 11 ill.; Boyle 1979, pp. 52, 54, 53 col. ill.; Brooklyn Museum 1979, p. 115 ill.; Forgey 1973, p. 24 col. ill.; Foshay 1984, pp. 62, 126-127, 144 col. ill.; Gerdts 1980, pp. 139, 67 col. ill.; Gerdts 1981, p. 222, fig. 9.7; Gerdts 1983, pp. 80, 138, 112 ill.; Gerdts 1984, p. 112, col. ill.; Hale 1957, p. 322 ill.

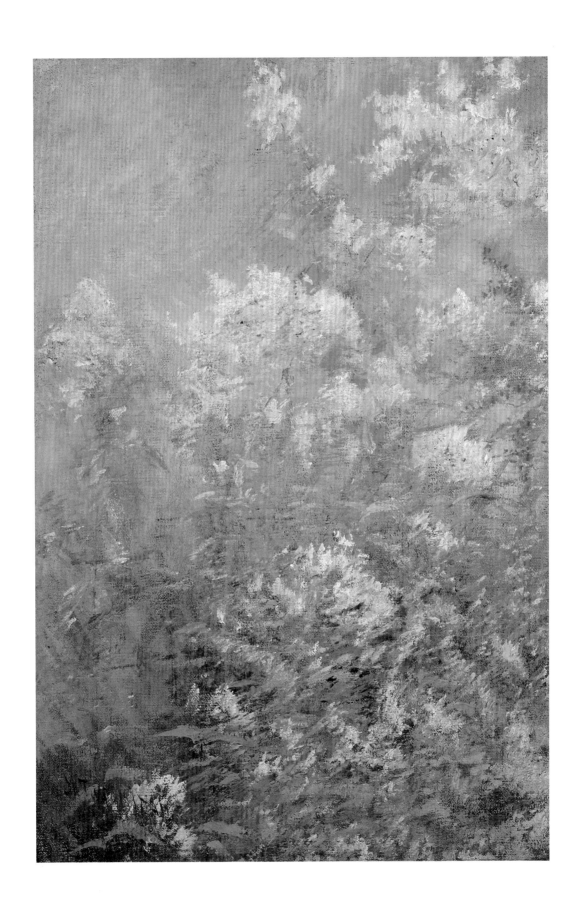

Plate 2

Wildflowers, ca. early 1890s

Oil on canvas
30¼ × 25¼ in. (76.8 × 64.1 cm.)
Signed lower right: *J. H. Twachtman*;
 middle left: *J. H. Twachtman*
Spanierman Gallery, New York

In this painting, which may depict the phlox flowers of his Greenwich garden, Twachtman delighted in the subtle juxtapositions of color and shape that nature presented. He rendered the work quickly and probably *en plein air*; animated cross-hatched strokes were used to depict foliage and thick daubs of impasto were applied to suggest the freshness and movement of the blossoms. In *The Flower Garden* (fig. 11), which is closely related to *Wildflowers*, Twachtman's process was far more labored, and the canvas was built up in dense layers of paint. He obviously enjoyed the effects made possible by a spontaneous method, which allowed him to capture his immediate response to the variety within the floral landscape, as well as that provided by a more concentrated effort. *Wildflowers* continues to communicate Twachtman's first experience of the subject.

PROVENANCE: Martha Scudder Twachtman (the artist's wife), Greenwich, Connecticut, until 1936; to J. Alden Twachtman (the artist's son), Greenwich, Connecticut, until 1941; to Charlotte Soutter (J. Alden Twachtman's niece), Greenville, South Carolina, until 1977; to (Sotheby Parke Bernet Inc., 27 October 1977, no. 48); to (Arvest Galleries, Inc., Boston); to present coll., 1987.

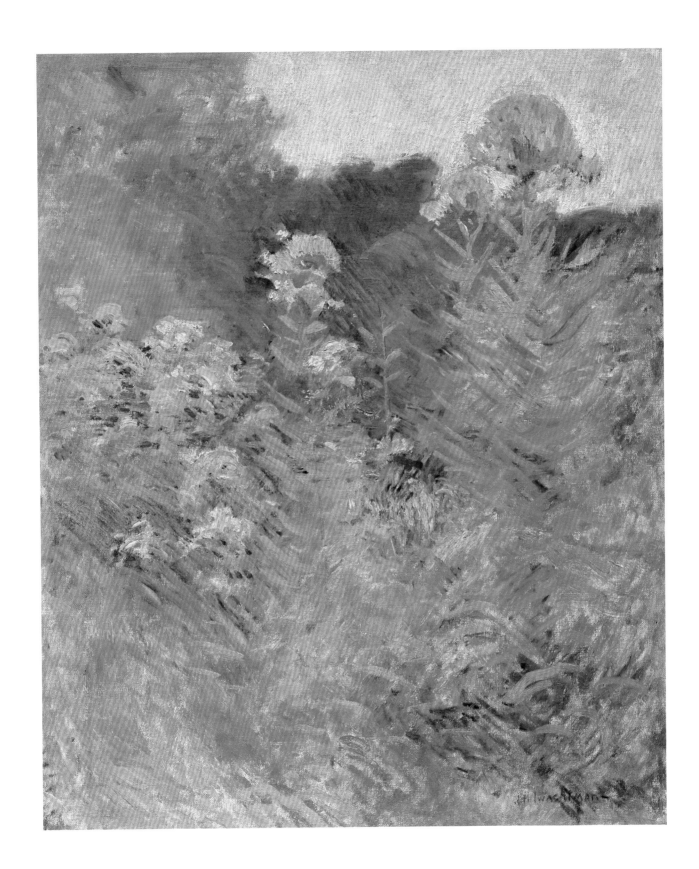

Plate 3

Tiger Lilies, ca. early 1890s

Oil on canvas
30 × 22 in. (76.2 × 55.9 cm.)
Signed middle left; *J.H. Twachtman*
Collection of Mr. and Mrs. Meyer P.
 Potamkin

In *Tiger Lilies*, Twachtman continues his break from the static formula of the traditional still life, expressing the energy and freedom of flowers in their natural environment. Using a vertical format, he eschews the broader landscape context and restricts the scene to the immediate area around the flowers. They rise from the dense, forested surrounding, challenging the flatness of the picture plane and standing out against the sky in the upper left corner. Both the forceful paint application and the low vantage point allow the viewer to experience the painting's unfolding drama, the rising crescendo of forms.

This may be the rendering of *Tiger Lilies* included in the 1893 exhibition at the American Art Galleries, a show Twachtman shared with J. Alden Weir, while a display of the works of Monet and Paul Albert Besnard appeared elsewhere in the same location. The early 1890s date is suggested by Twachtman's choice of an untended site and his use of loose and forceful yet controlled brushwork to convey his direct emotional response to the scene. Despite its delicate subject, *Tiger Lilies* is one of the artist's most powerful and vibrant images.

HALE: general cat. nos. 385-388, p. 470.

PROVENANCE: Martha Scudder Twachtman (the artist's wife), Greenwich, Connecticut, as of 1913; (Milch Galleries, New York); to present coll., 1964.

EXHIBITIONS: 1913 School of Applied Design, no. 17 (lent by Mrs. J. H. Twachtman); 1913 Buffalo Fine Arts Academy, no. 12 (lent by Mrs. J. H. Twachtman); 1980 William Benton Museum, no. 150; 1983 Montclair Art Museum (pp. 80, 138, 113 ill., unpaginated col. inset).

REFERENCES: *Albright Academy Notes* 1913, p. 66; Boyle 1974, p. 94 col. ill.; Gerdts 1983, pp. 80, 138, 113 ill., unpaginated col. inset.

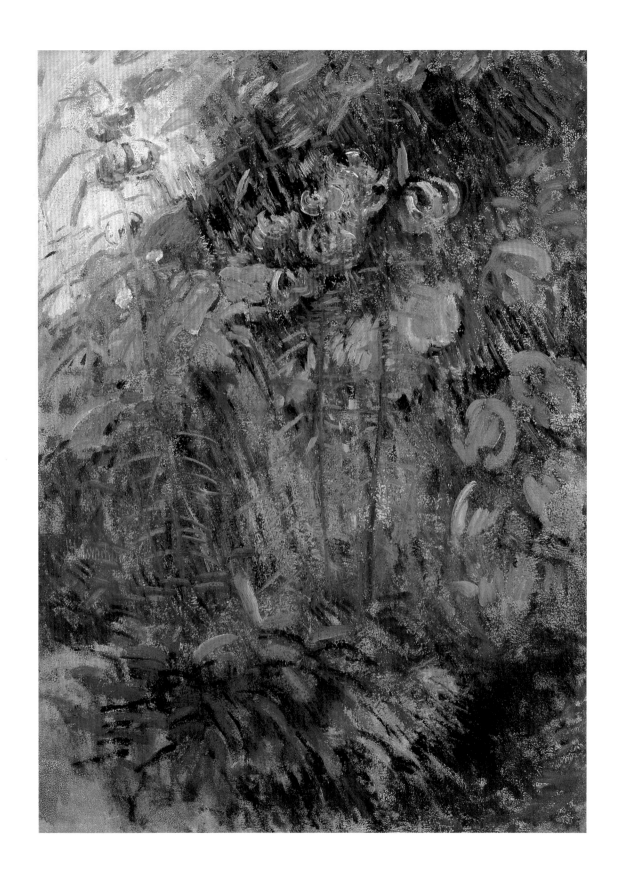

Plate 4

The Cabbage Patch, ca. mid-1890s

Oil on canvas
25 × 25 in. (63.5 × 63.5 cm.)
Private Collection

Depicted from the hill opposite Twachtman's Greenwich house, the view shown in *The Cabbage Patch* spans the full range of the garden plot and its dense plantings. It includes the skeletal outline of the back of the house—discernable by the gabled doorway and the columns of the open-air porch. The work shows the same view as *A Garden Path* (pl. 7), but from much farther away. Despite the more distant vantage point taken in *The Cabbage Patch*, the entire scene may be grasped at once. Twachtman achieves a sense of immediacy through both a panoramic composition and a varied paint application. Broad strokes of paint and large forms in the foreground progress to tighter brushwork and tiny details in the distance, such as the tiger lilies that hang in front of the house's porch (undoubtedly the same ones shown in close up in pl. 3 and fig. 8). *The Cabbage Patch* signals the shift in Twachtman's work from a naturalistic depiction of the wilder aspects of the landscape to a pleasure in expressing nature as abstract pattern and design.

PROVENANCE: Lewis P. Skidmore, Atlanta; to Mrs. Anne Skidmore Titus, Chicago; (Chappellier Galleries, New York); Dr. John J. McDonough, Youngstown, Ohio; (Sotheby Parke Bernet Inc., New York, 22 March 1978, no. 34); to present coll., 1978.

EXHIBITIONS: 1975 New Orleans Museum, no. 58 (p. 97 col. ill.); 1980 William Benton Museum, no. 139 (p. 22 col. ill.)

REFERENCES: Gerdts 1984, p. 110 col. ill.; Katzander 1981, p. 172 col. ill.

Plate 5

In the Greenhouse, ca. mid-1890s

Oil on canvas
25 × 16 in. (63.5 × 40.6 cm.)
Signed lower right: *J. H. Twachtman*
North Carolina Museum of Art, Raleigh

Although this painting is titled *In the Greenhouse*, the roof in the distance belongs to the barn that stood at the back reaches of Twachtman's garden. Moreover, the artist is not known to have had a greenhouse on his property, and the flowers depicted are definitely in the outdoors rather than in a conservatory setting. The certainty of Twachtman's paint handling, the lightness of his palette, and the crispness of his colors are characteristic of his style of the mid-1890s, a time when French Impressionism had more impact on his work than previously. In this painting, Twachtman expresses pleasure in both wild and more constrained aspects of nature. The planters in the foreground convey a sense of spatial order, however, just beyond, flowers rise up and fill the atmosphere with a symphonic array of color and form.

PROVENANCE: Miss Elizabeth Spencer, Philadelphia; (Coe Kerr Gallery, New York, 1970–1972); to present coll., 1973.

EXHIBITIONS: 1970 Coe Kerr Gallery, no. 42; 1975 Mint Museum, no. 38; 1983 Montclair Art Museum (pp. 138, 110 ill.); 1984 Whitney Museum (pp. 62, 109, 122 col. ill.).

REFERENCES: Anderson 1980, pp. 52, 53 col. ill.; Foshay 1984, pp. 62, 109, 122 col. ill.; Gerdts 1981, p. 223 ill.; Gerdts 1983, pp. 138, 110 ill.; North Carolina Museum, *Bulletin* 1974, p. 12 ill.; North Carolina Museum, *Bulletin* 1976, p. 26; *North Carolina Museum* 1983, p. 252 ill.

Plate 6

Azaleas, ca. late 1890s

Oil on canvas
30 × 24 in. (76.2 × 61 cm.)
Signed lower left: *J. H. Twachtman*
Maier Museum of Art, Randolph-Macon
 Woman's College, Lynchburg, Virginia

In *Azaleas*, Twachtman turns to the subject of the garden path, a favorite of French Impressionist Claude Monet and painted by other artists such as John Singer Sargent and Dennis Miller Bunker. The painting demonstrates Twachtman's increased pleasure in civilized nature during his late years in Greenwich. Rather than the chaotic wild view of the garden rendered in *Wildflowers* (pl. 2) and *Tiger Lilies* (pl. 3), works that convey the powerful forces of nature, *Azaleas* shows an ordered and carefully tended garden. The floral forms in the painting are treated more abstractly than in other garden paintings, presented as vibrant colorful masses. Twachtman delighted in the decorative pattern that they presented, in contrast with the solid shapes of path and barn. The formal order of the garden, the strong compositional design, and the generalized treatment suggest that *Azaleas* was painted toward the turn of the century.

HALE: cat. A, no. 32, p. 32.

PROVENANCE: Henry Smith, New York, as of 1915; (Milch Galleries, New York, 1922); J. K. Newman, New York; (American Art Association—Anderson Gallery, *Sale of the Collection of J. K. Newman*, 6 December 1935, no. 21); to (W. H. Weidman, agent for William Randolph Hearst); (Milch Galleries, New York, as of 1942); (Leo Elwyn & Co., 1943); (Milch Galleries, New York, 1945); to Mrs. Andrew C. Gleason, 1945; to present coll., 1945.

EXHIBITIONS: 1915 Panama-Pacific, no. 4064 (lent by Henry Smith); 1942 Babcock Galleries, no. 8; 1943 M. Knoedler and Co., no. 36; 1945 Milch Galleries, no. 12; 1949 Randolph-Macon, no. 11; 1953 Randolph-Macon, no. 56; 1966 Whitney Museum, no. 279 (p. 68 col. ill.); 1980 Henry Art Gallery (not listed in cat.); 1983 Montclair Art Museum (pp. 82, 138, 109 ill.); 1985 North Carolina Museum, no. 36 (p. 23 ill.).

REFERENCES: Gerdts 1983, pp. 82, 138, 109 ill.; Hale 1957, pp. 220, 219 ill.; Lane 1942, p. 29 ill.; Price 1972, pp. 175, 174 col. ill. ; Williams 1965, pp. 90, 91 ill.; Williams 1972-1973, p. 195 ill.; Williams 1977, pp. 158-159, 31 col. ill.

Plate 7

A Garden Path, ca. late 1890s

Oil on canvas
30 × 30 in. (76.2 × 76.2 cm.)
Private Collection

A sense of ease and composure exudes from *A Garden Path*. The view of the garden as orderly and civilized emerges in Twachtman's later renderings of it, and thus this painting probably dates from the late 1890s. The composition is harmonious: the garden path is balanced by the horizontal of the house, and the gable over the doorway provides a focal point for both. There is a clear progression of space, with flowers contained on either sides of the path. Plants in pots on the doorstep echo the symmetry of the divided garden and provide a feeling of welcome at the entryway to the house. Light is diffused throughout; even yellow flowers are generalized and merged with the soft green foliage. Twachtman returns here to the method of thin paint application used during his French period of the mid-1880s. He obviously decided not to build up the surface of the canvas with the dense layers apparent in other works, enjoying the overall unity achieved by the smooth treatment.

PROVENANCE: Quentin Twachtman (the artist's son); to John J. Twachtman (Quentin Twachtman's son); to (Kennedy Galleries, New York, late 1970s); to present coll., 1989.

EXHIBITIONS: 1988 Fairfield University, no. 24.

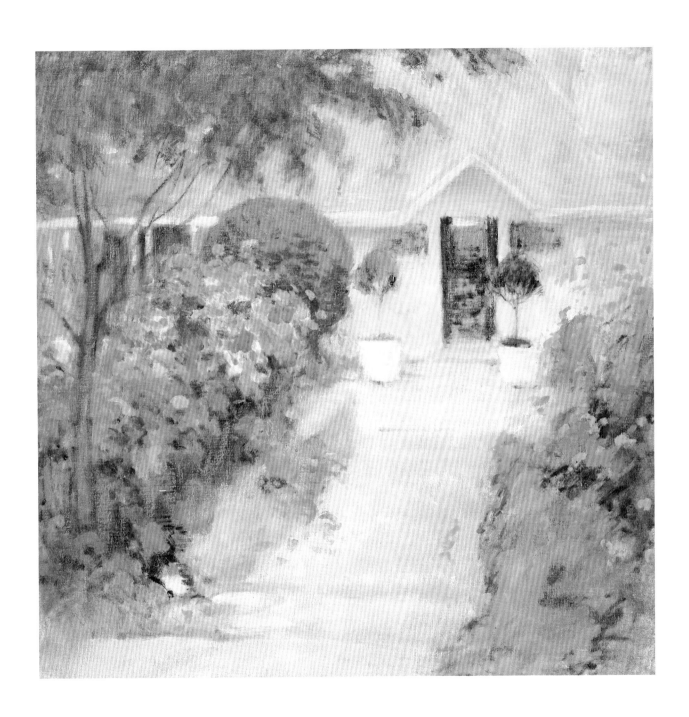

Plate 8

Flowers, ca. early 1890s

Oil on canvas
30¼ × 25 in. (76.8 × 63.5 cm.)
Pennsylvania Academy of the Fine Arts,
 Philadelphia, Gift of Mrs. Edward H.
 Coates (Edward H. Coates Memorial
 Collection)

Most of Twachtman's floral depictions in this exhibition present flowers growing freely in his garden or in the open fields. This painting is one of only two known works in the more conventional genre of the floral still life. As William Gerdts points out in his essay in this catalogue, the flowers depicted appear to be gladioli and the painting was undoubtedly the depiction of this subject shown in 1893 at the American Art Galleries and again in 1915 at the Panama-Pacific Exposition in San Francisco, when it was in the collection of Edward H. Coates (from whom the Pennsylvania Academy acquired it). The impressionist treatment that Twachtman used for *Flowers* suggests that the work was rendered during his Greenwich period. However, it is also possible that it predates the period because of the pale tonalities and the subject matter. Twachtman was not entirely comfortable with the depiction of cut flowers in a vase. Yet the flowers respond to air and mood as they do in his outdoor depictions. The artist used an animated paint application to reveal their freshness. A similar brushwork describes the background, and layers of toned pigment convey shifting light reflections in the room. Instead of a static presentation of the still-life subject, Twachtman conveys its vibrancy and ability to bring warmth to an empty space.

HALE: cat. A no. 173, p. 549.

PROVENANCE: (Silas S. Dustin, agent for the artist's estate); to John D. Trask, Philadelphia, 1907; to Mr. and Mrs. Edward H. Coates, Philadelphia; to present coll., 1923.

EXHIBITIONS: 1893 American Art Galleries, no. 27 (as *Gladiolus*); 1907 Pennsylvania Academy, no. 263 (as *Flowers*); 1915 Panama-Pacific, no. 4067 (as *Gladioli*, lent by Mr. Edward H. Coates, Esq.); 1923 Pennsylvania Academy, no. 17 (as *Still Life*).

REFERENCES: Gerdts 1981, p. 221; Gerdts and Burke 1971, p. 214 ill.; Hale 1957, p. 320 ill.

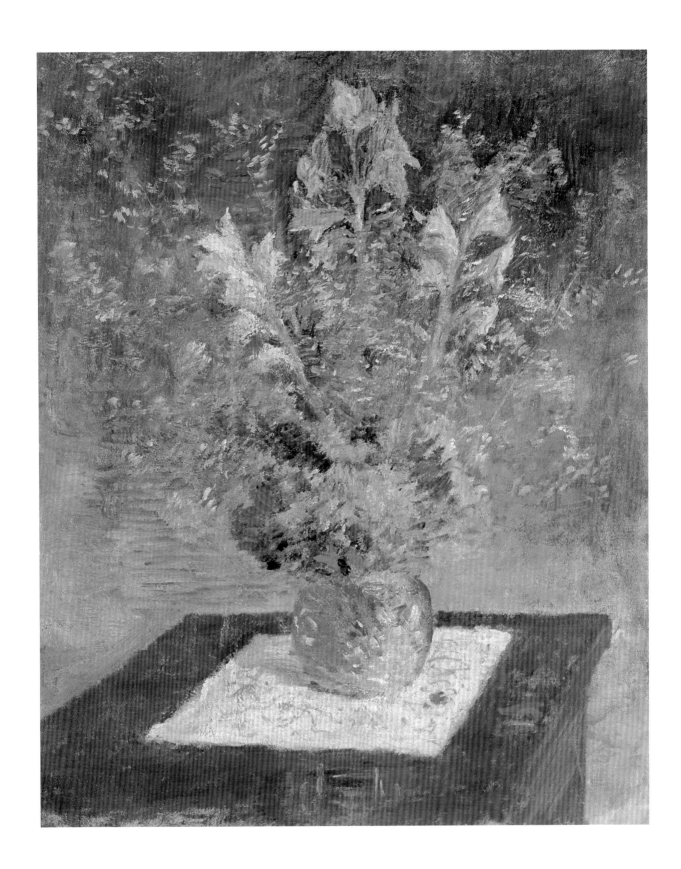

Plate 9

In the Sunlight, ca. 1893

Oil on canvas
30 × 25 in. (76.2 × 63.5 cm.)
Signed lower right: *J. H. Twachtman*
Private Collection

In the Sunlight depicts the artist's wife, Martha, seated on the back porch of the Greenwich house surrounded by the freely growing flowers of the family garden. The image of a female figure engaged in quiet contemplation and associated with aesthetic experience was one explored by countless artists during the late nineteenth century. Twachtman, however, separates himself from the characteristic idealized and posed depictions of women painted by his contemporaries. His aim was to capture the unplanned moment and express his immediate reaction to a subject. As he told a group of students in 1899:

> If you are working from the figure do not do the conventional sort of thing that we find in a sketch-class model, but rather the unconscious attitude. The charm of childhood lies in its unconsciousness. Do we like people who pose? No. A figure that is obviously arranged affects one in the same way. . . . Do not do the girl with a book unless you can make us see something new.[1]

Twachtman's main concern in this painting is the rendering of the varied effects of light and atmosphere on the figure in the outdoor environment. The landscape is filled with vivid color and light. The figure's robe swells gently with movement, picking up the full range of reflection and shadow falling on its surface. The garden is also rendered with active brushstrokes. Petals blend together with the lush green landscape behind the figure, while in the foreground, individual flowers emerge, their blossoms painted with thick impasto.

Twachtman obviously took great pleasure in this painting as he displayed it in numerous exhibitions, including it in the important 1893 exhibition at the American Art Galleries, and showing it three times in Philadelphia during the 1890s. His daughter, Violet, had a similar fondness for it, as she acquired it from the well known collector John Gellatly, who had purchased it from Twachtman's 1903 estate sale. *In the Sunlight* provided the artist with the challenge of combining landscape, figure, and flower painting. All three are integrated fully in the canvas with no one genre predominating. The work conveys "the spirit of the place and the delight with which his work was done."[2]

HALE: cat. A, no. 614, pp. 572–573; and general cat., no. 615, p. 498.

PROVENANCE: (American Art Galleries, New York, *Sale of the Work of John H. Twachtman*, 19 March 1903, no. 82); to John Gellatly; to Violet Twachtman Baker (the artist's daughter), New York, 1927; by descent through the family; to (Spanierman Gallery, 1987); to present coll., 1988.

EXHIBITIONS: 1893 American Art Galleries, no. 15; 1893 St. Botolph Club, no. 9; 1894 Pennsylvania Academy, no. 298; 1895 Pennsylvania Academy, no. 298 (as *In the Sun*); 1897 Cincinnati Art Museum, no. 34; 1898 National Academy of Design, no. 327; 1898 Art Club of Philadelphia, no. 141; 1901 Cincinnati Art Museum, no. 48 (as *In the Sunshine*); 1928 Milch Galleries, no. 7; 1932 Brooklyn Museum, no. 110a (as *In the Sunshine*).

REFERENCES: *Art Amateur* 1898, p. 131; Hall 1897, p. 179; *International Studio* 1898, p. xiv; *New-York Daily Tribune* 1903, p. 9; *Philadelphia Daily Telegraph* 1898, p. 6; *Philadelphia Inquirer* 1898, p. 4; *Philadelphia Times* 1898, p. 6; *Public Ledger–Philadelphia* 1898, p. 3.

[1] "An Art School at Cos Cob," *Art Interchange* 43 (September 1899): 56.
[2] J. Alden Weir, "John H. Twachtman: An Estimation," *North American Review* 176 (April 1903): 562.

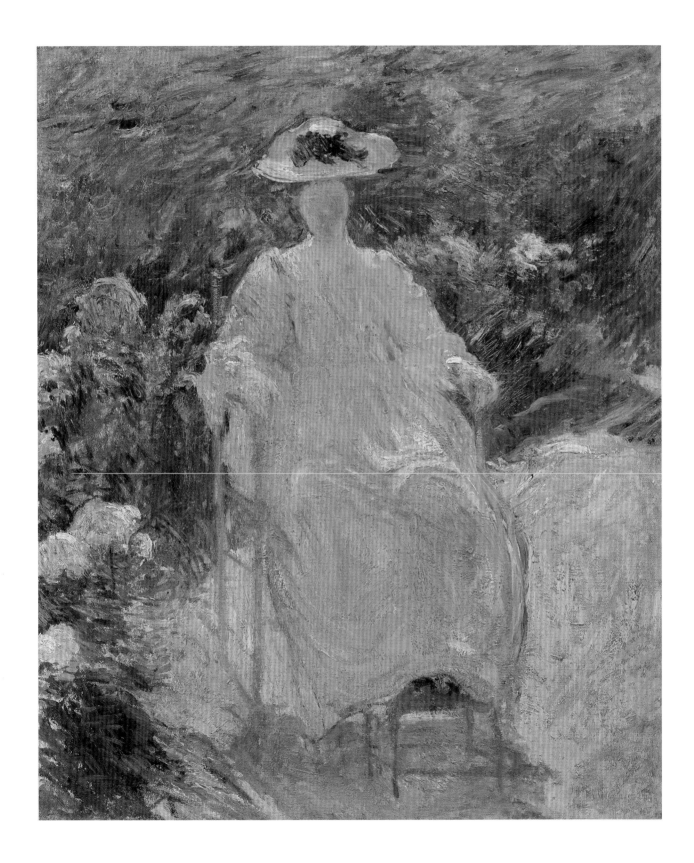

Plate 10

Figure in Sunlight, ca. mid-1890s

Oil on canvas
26¼ × 21¼ in. (66.7 × 54 cm.)
Signed middle left: *J. H. Twachtman*
National Museum of American Art,
 Smithsonian Institution, Washington, D.C.,
Gift of John Gellatly

In *Figure in Sunlight*, Twachtman depicted his wife, Martha, under the trellis that covered the porch at the back of the Greenwich house. There are many similarities between this painting and *In the Sunlight* (pl. 9), which also shows Martha seated in the center of an outdoor landscape, however for this work, Twachtman chose a more varied lighting, selecting a setting that was half shaded and half open and strongly lit. Sunlight falls strongly on the stone shed that extended outward from the back of the Greenwich house. Seated under the trellis that partially covered the backyard porch, the figure is protected from the heat of the day. She assumes a contemplative and quiet demeanor, her face shaded and her hands folded, while natural light filters across her dress, casting a soft reflective glow.

The subject of a quietly reflective woman seated within the confines of an interior space was a popular subject for many artists of the late nineteenth century and was explored most often by artists of the Boston School. Twachtman's depiction opposes the conventions associated with imagery of women in interiors that were followed by Edmund Tarbell, Frank Benson, or William Paxton. Rather than painting in a tight realistic style and surrounding the figure with aesthetic objects, Twachtman treats it in generalized terms and focuses on conveying a mood of serenity. Martha's inward concentration, expressed by her folded hands and calm pose, set the tone of the work. The angles of the porch, window, and slope of the stone structure in the landscape beyond the figure echo her pose and stillness.

HALE: cat. A no. 171, p. 549.

PROVENANCE: Martha Scudder Twachtman (the artist's wife), Greenwich, Connecticut; to (Frank K. M. Rehn, New York); to John Gellatly, 1920; to present coll., 1929, Gift of John Gellatly.

EXHIBITIONS: 1966 Cincinnati Art Museum, no. 79.

REFERENCES: Clark 1924, p. 54 ill.; Hale 1957, p. 51; National Museum of American Art 1983, p. 196; Smithsonian Institution 1933, p. 17; Smithsonian Institution 1954, p. 16; Tucker 1931, pl. 36.

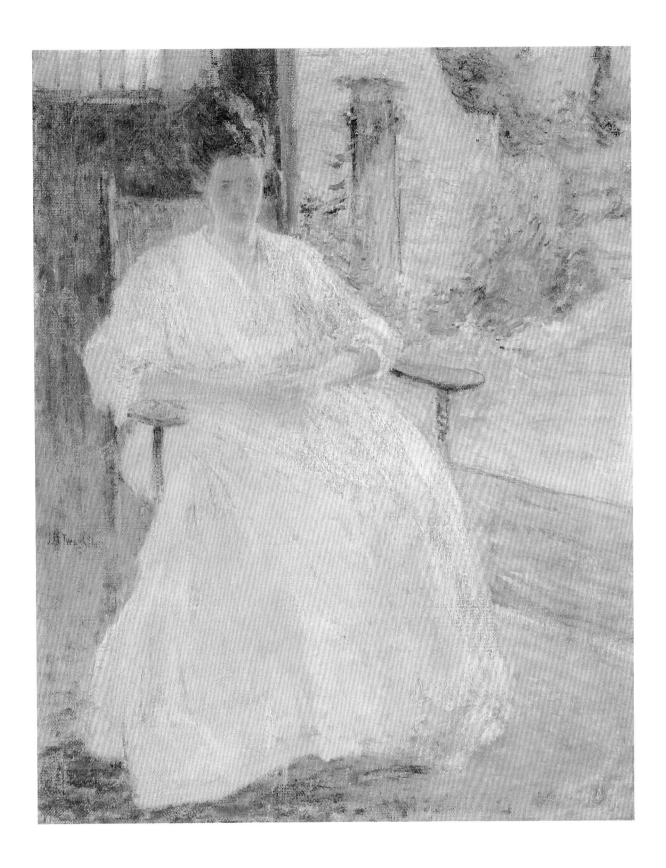

Plate 11

On the Terrace, ca. 1897

Oil on canvas
25¼ × 30⅛ in. (64.1 × 76.5 cm.)
Signed lower left: *J. H. Twachtman*
National Museum of American Art,
 Smithsonian Institution, Washington, D.C.
 Gift of John Gellatly

Of the six works that Twachtman submitted to the first exhibition of the Ten American Painters in 1898, *On the Terrace* received the greatest amount of attention and commendation from the press. The *New York Sun* reviewer wrote that it was the most pleasing of Twachtman's canvases, "and the one containing most of the true feeling of out of doors."[1] Another critic noted that the work conveyed "a cheerful, gay impression of summer time."[2] The painting was also recognized for fulfilling the aesthetic requirements of decorative painting. The reviewer for the *New York Evening Post* noted Twachtman's ability to "see nature in decorative patterns, resplendent in light; yet harmonized by the atmospheric envelope."[3]

On the Terrace may be Twachtman's only work in which three subjects—figures, the Greenwich house, and the garden—are given equal attention. The three are separated, yet Twachtman successfully links them through the composition. The flowers serve a pivotal function, framing the figures and thrusting an angled projection forward from the house. Sunlight also unifies the arrangement. Though equally intense throughout, it creates different effects on each subject. Flowers painted with thick impasto applied directly to the canvas express ripeness and vitality. The figures are more softly painted, with white dresses picking up reflected colored light. The house appears as a smooth gray plane that provides a protective backdrop to the image.

The painting expresses Twachtman's interest in domestic subject matter combined with the cultivated landscape during his late Greenwich years. The garden is shown at its fullest. The family is grouped as in a classical image. Flowers in full bloom surround and envelop figures. The house gable and doorway are crowned by a blossoming arched vine.

HALE: cat. A no. 622, p. 573.

PROVENANCE: John Gellatly, 1899; to present coll., 1929, Gift of John Gellatly.

EXHIBITIONS: 1898 Durand-Ruel Galleries, no. 35; 1898 St. Botolph Club, no. 9; 1901 Durand-Ruel Galleries; 1907 Lotos Club, no. 14 (lent by John Gellatly).

REFERENCES: *Art Bulletin* [1907], p. 1; *Boston Evening Transcript* 1898, p. 16; de Kay 1918, p. 76; Goodrich 1965, p. 80 ill.; Hale 1957, pp. 226, 227 ill.; National Museum of American Art 1983, p. 196; *New York Mail and Express* 1898, p. 7; *New York Sun* 1898, p. 6; *New York Times* 1898, p. 6; *New York Times* 1901, p. 8; Smithsonian Institution 1933, p. 17; Smithsonian Institution 1954, p. 16; Van Dyke 1898, p. 7.

[1] "Art Notes," *New York Sun*, 30 March 1898, p. 6.
[2] "The Fine Arts: Exhibition by Ten American Painters at the St. Botolph Club," *Boston Evening Transcript*, 27 April 1898, p. 16.
[3] "Ten American Painters," *New York Evening Post*, 1 April 1898, p. 7.

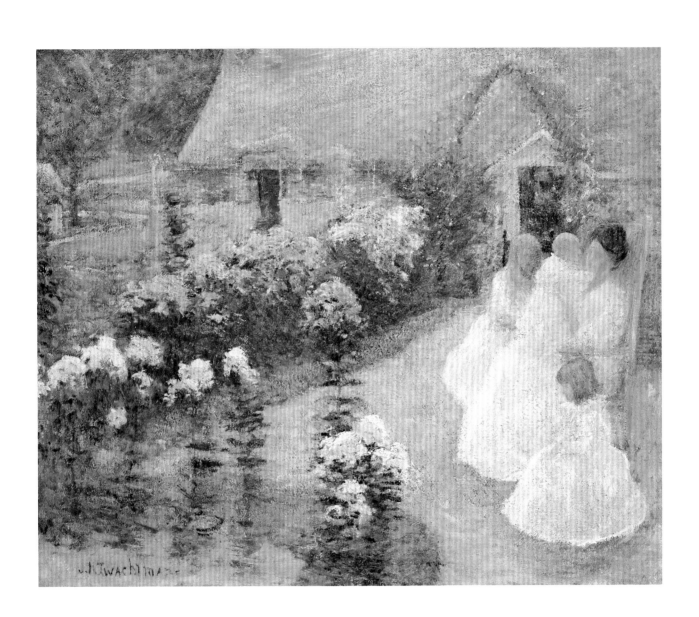

Plate 12

Mother and Child, ca. 1897

Oil on canvas
45½ × 36 in. (115.6 × 91.4 cm.)
Private Collection

Martha Scudder Twachtman, the artist's wife, and their sixth child, Violet, are shown in front of the Greenwich house in *Mother and Child*. This work was probably executed about 1897 since Violet, who was born in 1895, appears to be approximately two years old. The inclusion of the portico in the left background also verifies the dating. Designed by architect Stanford White, it was built onto the house after 1895. The covered veranda behind the figures was also added in the mid-1890s.

The composition of *Mother and Child* suggests the traditional image of Madonna and Child in the modern interpretation it received in the late nineteenth century by such artists as Mary Cassatt and Abbott Thayer. Twachtman, however, in his adaptation of the subject, is primarily concerned with the arrangement and interaction of the white shapes that dominate the work. In this painting, as in the snow scenes of his Greenwich years, he demonstrates a concern for the varied effects of outdoor light and the colors of nature reflected on white, planar forms. Dappled, multicolored reflections may be seen in the walls of the house and in the portico, and more subtle tonalities appear in the dresses of the figures.

Twachtman expresses his affection for his wife and daughter through the portrayal, centering the figures in the composition and linking them with the sparkling, refreshing qualities of the summer day. The ripe flowers glisten on the terrace above them and the portico behind them is softened by hanging foliage which adds a note of ideality to the presentation.

HALE: general cat. no. 636, p. 499.

PROVENANCE: Violet Twachtman Baker (the artist's daughter); by descent through the family.

EXHIBITIONS: 1966 Cincinnati Art Museum, no. 50.

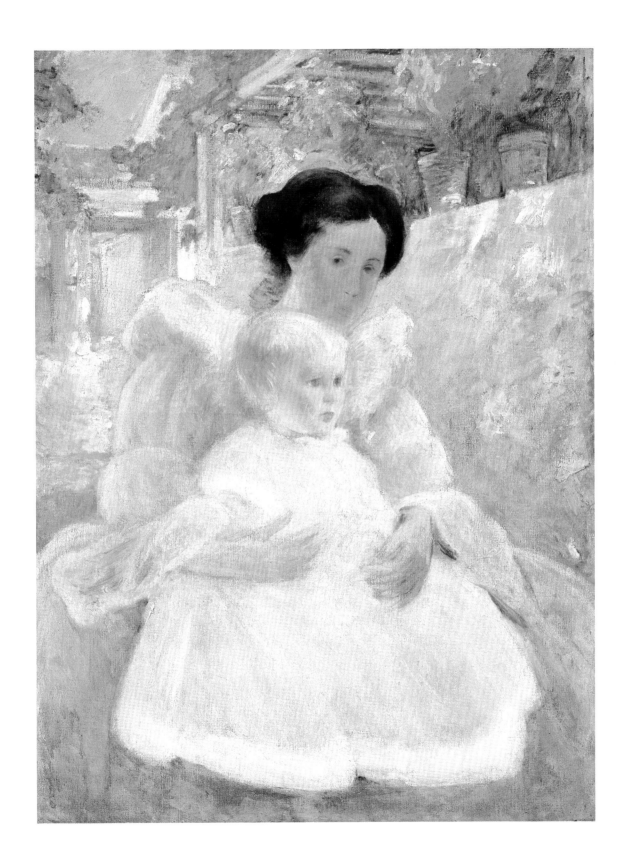

Plate 13

The Portico, ca. late 1890s

Oil on canvas
30 × 30 in. (76.2 × 76.2 cm.)
Signed lower right: *J. H. Twachtman*; stamped
 lower left in red: *Twachtman Sale*[1]
Private Collection

The Portico depicts the front of Twachtman's Round Hill Road house and features the columned doorway, designed by Stanford White and attached to the artist's residence after 1895. The painting conveys the theme of domestic felicity that emerges in his works of the late 1890s. This theme is formally enhanced by the harmonious and ordered composition—a balanced structure of horizontals and verticals set into a square-shaped canvas. The classical facade establishes the basic geometry, and the tree at the left repeats the verticality of the columns and braces the left side of the painting, while the pots on the doorstep, with their tall plants, accentuate the portico's symmetry. The family group, composed of three figures (undoubtedly the artist's wife, Martha, and two children, perhaps Violet, born 1895, and Godfrey, born 1897), luxuriate in the sunshine, protected by the enlarged stairwell. Their diminished scale in relation to the house contributes to the elegant and almost grand appearance of the artist's residence. The late afternoon light sheds a warm glow over the front lawn, dispersing softly colored reflections on the house walls.

HALE: cat. A, no. 483, p. 565.

PROVENANCE: (American Art Galleries, New York, *Sale of the Work of the Late John H. Twachtman*, 19 March 1903, no. 86); to C. R. L. Putman; Mr. John F. Braun, Philadelphia, 1920; Mrs. John F. Braun, Philadelphia, 1920; (G. Castano Galleries, by 1968); (Hirschl & Adler Galleries, Inc., New York, 1968–1974); (Christie's, New York, 23 May 1979, no. 127); (Andrew Crispo Gallery, New York); present coll., 1980.

EXHIBITIONS: 1968 Ira Spanierman, no. 16; 1968 Hirschl & Adler, no. 89 (ill.); 1971 Lowe Art Museum, no. 175 (as *His Family–The Portico*, lent by Hirschl & Adler Galleries, Inc.).

[1] The stamp indicates that the painting was sold in Twachtman's estate sale in 1903 at the American Art Galleries, New York.

Plate 14

Summer Afternoon, ca. 1900–1902

Oil on canvas
25 × 16 in. (63.5 × 40.6 cm.)
Signed lower right: *J. H. Twachtman*
Private Collection

Painted in the spontaneous manner of his Gloucester period style, *Summer Afternoon* is Twachtman's boldest and most direct rendering of the figure in the outdoor environment.[1] Landscape motifs and figures are depicted in a quick, sketchy technique that conveys the fresh experience of the moment. A female figure, probably the artist's wife, Martha, walks across the bridge, her shape echoed by the sail of the boat at the opposite shore, while children sitting at the bridge's far end are summarily treated and almost merged with the landscape background. Twachtman constructed the bridge in the late 1890s to span Horseneck Brook, which ran through his Greenwich property. Featured in several works, the bridge is integrated into dense, layered decorative arrangements. However, in *Summer Afternoon*, it is the primary motif in the painting, extending foreground to background and casting a dark green reflection in the water below. The dashing, confident brushstrokes as well as the strong juxtaposition of forms express the pleasure that the artist received from seeing his family enjoying the sunlit natural beauty of his Greenwich property.

PROVENANCE: (M. Knoedler & Co., New York); present coll., ca. 1976.

[1] For information on Twachtman's Gloucester period, see John Douglass Hale, Richard J. Boyle, and William H. Gerdts, *Twachtman in Gloucester: His Last Years, 1900–1902*, exh. cat. (New York: Ira Spanierman Gallery, 1987).

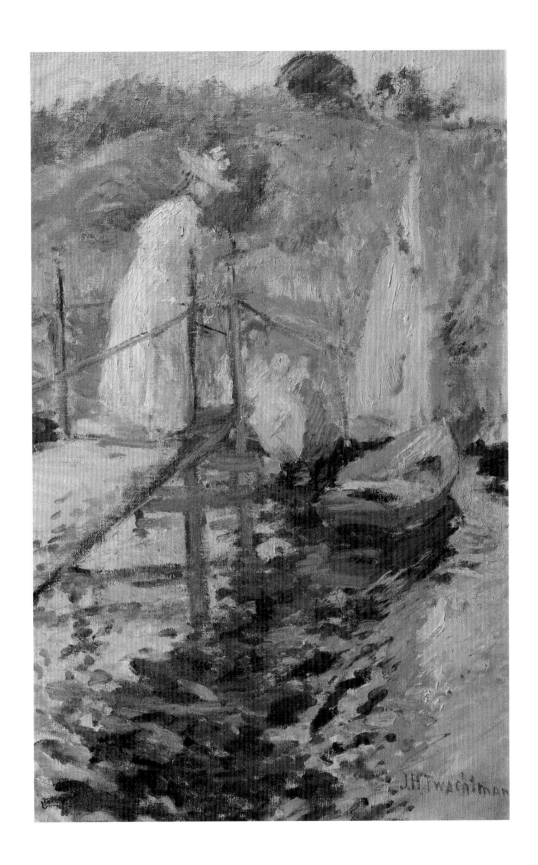

Plate 15

Tiger Lilies, ca. 1889–1891

Pastel on paper
17½ × 11¾ in. (44.5 × 29.8 cm.)
Signed lower left: *J. H. Twachtman*
National Museum of American Art,
 Smithsonian Institution, Washington, D.C.,
 Gift of John Gellatly

Twachtman's 1891 exhibition at the Wunderlich Gallery in New York included forty-three works, thirty of which were pastels. Indeed, the large number of pastels demonstrates the confidence that Twachtman had in the medium during his early years in Greenwich and suggests that he felt that pastels best represented his artistic skills at the time. *Tiger Lilies*, possibly shown in the exhibition, exemplifies the qualities noted by critics who reviewed the show. As one wrote, "The certainty of the painter's touch was most remarkable in several sketches of wild flowers, of apparently the slightest description, yet recognizable at a glance."[1]

In this rendering, Twachtman shows tiger lilies as gentle and refined flowers, in comparison with those in the paintings created a couple years later, in which he brings out their bright color and expansive assertiveness (see pl. 3 and fig. 8). Softly tousled by the wind, the blossoms sway and blend together, susceptible to forces of nature. Yet they resist full acquiescence; several flowers stand on their own, while others staunchly fend off the countering force. Twachtman expresses the simultaneous fragility and strength of his subject. *Tiger Lilies* demonstrates Twachtman's ability to "lend to his treatment something of the spirit of the thing itself. . . . the painted flowers of the field seem imbued with the delicacy of their own nature."[2]

HALE: cat. A no. 989, p. 590.

PROVENANCE: (Milch Galleries, New York); to John Gellatly; to present coll., 1929, Gift of John Gellatly.

REFERENCES: Smithsonian Institution 1933, p. 18; Smithsonian Institution 1954, p. 16.

[1] "My Notebook," *Art Amateur* 24 (April 1891): 116.
[2] Eliot Clark, "John Henry Twachtman (1853–1902)," *Art in America* 7 (April 1919): 137.

Plate 16

Weeds and Flowers, ca. 1889–1891

Pastel on paper board
19 × 15 in. (48.3 × 38.1 cm.)
Signed lower left: *J.H. Twachtman*
Collection of Nancy and Ira Koger

The tiny clusters and long thin stems of the plants depicted in *Weeds and Flowers* are close to those of the wild ageratum weed, and it is possible that this is one of the two depictions of ageratum shown in Twachtman's 1891 exhibition at the Wunderlich Gallery, New York. In the early 1890s, Twachtman was especially compelled by the natural vegetation of his Greenwich property. As he wrote to J. Alden Weir in 1892, "The foliage is changing and the wild-flowers are finer than ever. There is greater delicacy in the atmosphere and the foliage is less dense and prettier. The days are shorter which gives us a chance to see more of early morning effects."[1]

Twachtman captures the transitive qualities of the flowers in this work, rendering their litheness and weightlessness as they hover in the misty atmosphere. Blossoms seem to dissolve and re-form themselves as we look at them. Twachtman's ability to convey his direct experience of the flowers was recognized by a reviewer: "The flower pieces in pastel which seem at first hardly more than a ghost of the blossoms, assume outline and consistency."[2]

The works shown in 1891 were compared by many reviewers to those of James McNeill Whistler, and Twachtman's choice of a restricted palette, a light and sparing application of the medium, and the incorporation of the color of the paper into the design suggest the pastel approach of Whistler. One reviewer noted that "Like Whistler, [Twachtman] uses for pastels often a brown, rough paper and makes the tone of the paper tell."[3]

PROVENANCE: (Milch Galleries, New York); (A. C. A. American Heritage Gallery, Inc., New York); (Sotheby Parke Bernet Inc., New York, 4 December 1980, no. 42); to Hirschl & Adler Galleries, Inc., New York); to present coll., 1981.

EXHIBITIONS: 1928 Milch Galleries.

[1] [John H.] Twachtman, Greenwich [Conn.] to [J. Alden] Weir [Branchville, Conn.], 26 September 1892, Weir Family Papers, MSS 41, Harold B. Lee Library, Archives and Manuscripts Brigham Young University, Provo, Utah.
[2] "Art Notes," *New York Times*, 12 April 1891, p. 12.
[3] "Art Notes," *New York Times*, 9 March 1891, p. 4.

Plate 17

Wildflowers, ca. 1889–1891

Pastel on paper
17½ × 13 in. (44.5 × 33 cm.)
Signed lower right: *JHT*
Private Collection

This is one of Twachtman's most spare and simple compositions, with flowers depicted in a straightforward and gentle manner on a rough-surfaced bare paper. The blossoms are delicate, shown at the point of greatest freshness and frailty. The work typifies Twachtman's ability to endow a modest, commonplace subject with grace and elegance. The flowers are carefully and accurately rendered and at the same time appear natural and informal. Observing the pastels in Twachtman's 1903 estate sale, one reviewer recognized these qualities, asking the reader to "Witness the beautiful pastels, especially 'The Pasture,' 'Wild Flowers' and 'Meadow Flowers.' In all these things we get some casual bit of nature captured in its most artless aspect with the most searching sympathy and wonderful precision."[1]

PROVENANCE: Violet Twachtman Baker (the artist's daughter); by descent through the family; to (Spanierman Gallery, New York, 1987); to present coll., 1989.

[1] "Art Exhibitions," *New-York Daily Tribune*, 21 March 1903, p. 9.

Plate 18

Trees in a Nursery, ca. 1889–1891

Pastel on paper
18 × 22 in. (45.7 × 55.9 cm.)
Collection of Mr. and Mrs. Raymond J.
Horowitz

Twachtman's responsiveness to Whistler's pastel style is apparent in the delicate and minimal treatment used for this work. Adopting a limited color scheme, a simplified composition, and incorporating the beige tone of the paper into the composition, Twachtman demonstrates his adherence to Whistler's aesthetic. *Trees in a Nursery* also conveys Twachtman's feeling for the order and design inherent in the landscape. The rows of plantings set out like perspective lines in a conventional landscape depiction pull the viewer toward the tree in the left middle ground. Although this ordering device suggests the continued impact of Twachtman's academic training, he also uses it to create a compelling arrangement. The composition revolves around the tree at the left with rows of plants radiating from it; even the horizon line seems to project from it. Rather than using a perspectival scheme to draw the viewer into the distance, Twachtman employs it to convey his feeling for natural patterns in the landscape. The open, hilly terrain depicted in *Trees in a Nursery* suggests that the work may have been rendered in Branchville, Connecticut, near the home of J. Alden Weir, where Twachtman spent much time in the late 1880s and early 1890s. Twachtman included a depiction of Weir's farm in his 1891 exhibition at the Wunderlich Gallery, and a critic noted it was "delicious in color."[1] This would certainly be a fitting description for *Trees in a Nursery*, one of Twachtman's most accomplished and engaging pastels.

HALE: cat. A no. 1031, p. 592.

PROVENANCE: Martha Scudder Twachtman (the artist's wife), Greenwich, Connecticut; Mr. and Mrs. Godfrey Twachtman (Godfrey Twachtman was the artist's son), Independence, Missouri; (Milch Galleries, New York,·1967); to present coll., 1967.

EXHIBITIONS: 1968 Ira Spanierman, no. 33 ill.; 1973 Metropolitan Museum, no. 19 (p. 67 ill.); 1987 Hirschl & Adler, no. 25 (p. 34 col. ill.).

REFERENCES: Pilgrim 1978, p. 59 ill.; Stebbins 1976, p. 227.

[1] "The World of Art: An Impressionist's Work in Oil and Pastel–Mr. J. H. Twachtmann's [sic] Pictures," *New York Mail and Express*, 26 March 1891, p. 3.

Plate 19

Irises, ca. mid-1890s

Pastel on paper
17½ × 13¾ in. (44.5 × 34.9 cm.)
Signed lower left: *J. H. Twachtman*
Collection of Ira and Nancy Koger

Twachtman's depiction of *Irises* differs from his renderings of other wildflowers. In this instance, his treatment is much freer, with pastel applied in a sketchy manner. Forms are presented large scale and close up, and there is no concern for detail or specificity. The delineation of atmosphere defers to a delight in the movement of flowers and their overall patterning effect. *Irises* may date from the mid-1890s, a time when Twachtman began to work in a more spontaneous manner, expressing a direct response to light, color, and form in the landscape. This approach is most evident in paintings created at the time, however, *Irises* suggests that he began to work in a more immediate mode in the creation of some pastels as well.

PROVENANCE: (Coe Kerr Gallery, New York); to present coll., 1984.

EXHIBITIONS: 1985 Rollins College.

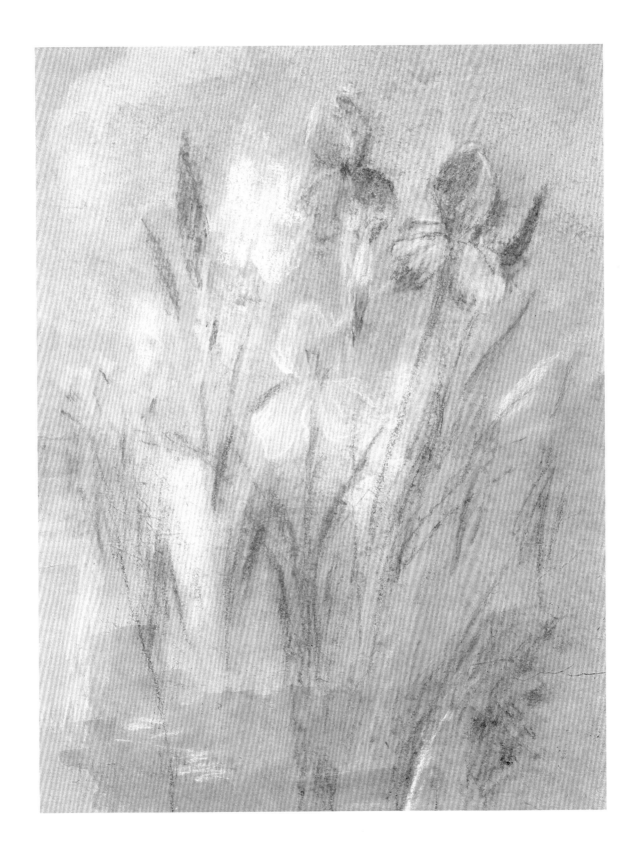

Plate 20

Landscape, ca. mid-1890s

Pastel on paper board
13¼ × 13¼ in. (33.7 × 33.7 cm.)
Signed lower right: *J. H. Twachtman*
Collection of Erving and Joyce Wolf

For this rendering, Twachtman eschews the panoramic viewpoint used for *Trees in a Nursery* (pl. 18), depicting the subject from a direct frontal angle. The immediate impact of the scene is conveyed through the *in situ* composition, which plunges the spectator into the garden's midst, and by the square format that emphasizes decorative surface patterns over pictorial depth. The site of the work appears to be an untended meadow where wildflowers are growing, or possibly Twachtman's garden rendered abstractly and spontaneously. However, rather than identify a specific place, Twachtman expresses the orchestration of natural elements and general relationships of forms and colors. Flowers and trees are treated as abstract shapes rather than in a detailed and precise manner. The shimmering light of the spring day is conveyed by sketchy white pastel in the foreground and in the sky.

PROVENANCE: (Bernard Danenberg Galleries, New York); (Sotheby Parke Bernet Inc., New York, 26 January 1974, no. 611); to present coll., 1974.

EXHIBITIONS

1893 American Art Galleries | American Art Galleries, New York, *Paintings, Pastels, and Etchings by J. Alden Weir and J. H. Twachtman*, May 1893.

1893 St. Botolph Club | St. Botolph Club, Boston, *An Exhibition of Oil Paintings by Messrs. Weir and Twachtman*, 27 November–9 December 1893.

1894 Pennsylvania Academy | Pennsylvania Academy of the Fine Arts, Philadelphia, *Sixty-Fourth Annual Exhibition*, 17 December 1894-23 February 1895.

1895 Pennsylvania Academy | Pennsylvania Academy of the Fine Arts, *Sixty-Fifth Annual Exhibition*, 23 December 1895–22 February 1896.

1897 Cincinnati Art Museum | Cincinnati Art Museum, *Spring Exhibition of Works by American Artists*, 22 May–5 July 1897.

1898 National Academy of Design | National Academy of Design, New York, *Seventy-Third Annual Exhibition*, 28 March–14 May 1898.

1898 Durand-Ruel Galleries | Durand-Ruel Galleries, New York, *First Exhibition: Ten American Painters*, 31 March–16 April 1898.

1898 St. Botolph Club | St. Botolph Club, Boston, *An Exhibition of Paintings by Ten American Painters*, 25 April–14 May 1898.

1898 Art Club of Philadelphia | The Art Club of Philadelphia, *Tenth Annual Exhibition of Oil Paintings and Sculptures*, 14 November–11 December 1898.

1901 Durand-Ruel Galleries | Durand-Ruel Galleries, New York, *Paintings and Pastels by John H. Twachtman*, March 1901.

1901 Cincinnati Art Museum | Cincinnati Art Museum, *Exhibition of Sixty Paintings by Mr. John H. Twachtman Formerly Resident in Cincinnati*, 12 April–16 May 1901.

1907 Lotos Club | Lotos Club, New York, *Exhibition of Paintings by the Late John H. Twachtman*, January 1907.

1907 Pennsylvania Academy | Pennsylvania Academy of the Fine Arts, Philadelphia, *102nd Annual Exhibition*, 21 January–24 February 1907.

1913 School of Applied Design | New York School of Applied Design for Women, *Fifty Paintings by the Late John H. Twachtman*, 15 January–15 February 1913.

1913 Buffalo Fine Arts Academy | Buffalo Fine Arts Academy, Albright Art Gallery, *Paintings and Pastels by the Late John H. Twachtman*, 11 March–2 April 1913.

1915 Panama-Pacific | Department of Fine Arts, San Francisco, *Panama-Pacific International Exposition*, 20 February–4 December 1915.

1923 Pennsylvania Academy | Pennsylvania Academy of the Fine Arts, Philadelphia, *The Edward H. Coates Memorial Collection*, 3 November 1923–[end of the year].

1928 Milch Galleries | Milch Galleries, New York, *An Important Exhibition of Paintings and Pastels by John H. Twachtman*, 12–24 March 1928.

1932 Brooklyn Museum	The Brooklyn Museum, New York, *Exhibition of Paintings by American Impressionists and Other Artists of the Period, 1880–1900*, 18 January–28 February 1932.
1939 Munson-Williams-Proctor	Munson-Williams-Proctor Institute, Utica, New York, *Presenting the Work of John H. Twachtman, American Painter*, 5–28 November 1939.
1942 Babcock Galleries	Babcock Galleries, New York, *Paintings, Water Colors, Pastels by John H. Twachtman*, 9–28 February 1942.
1943 M. Knoedler and Co.	M. Knoedler and Co., New York, *American Landscape Painting from 1750*, 17 May–11 June 1943.
1945 Milch Galleries	Milch Galleries, New York, *Paintings by American Artists: Late 19th and Early 20th Centuries*, May 1945.
1949 Randolph-Macon	Randolph-Macon Woman's College Art Gallery, Lynchburg, Virginia, *Thirty Paintings from the Randolph-Macon Woman's College Art Collection*, 5 May–7 June 1949.
1953 Randolph-Macon	Randolph-Macon Woman's College Art Gallery, Lynchburg, Virginia, *Selected Paintings from the College Collection*, 15–28 March; 8–21 April 1953.
1960 Brooklyn Museum	The Brooklyn Museum, New York, *Victoriana: An Exhibition of the Arts of the Victorian Era in America*, 7 April–5 June 1960.
1966 Whitney Museum	Whitney Museum of American Art, New York, *Art of the United States: 1670-1966*, 28 September–27 November 1966.
1966 Cincinnati Art Museum	Cincinnati Art Museum, *John Henry Twachtman: A Retrospective Exhibition*, 7 October–20 November 1966.
1968 Ira Spanierman	Ira Spanierman Inc., New York, *John Henry Twachtman, 1853-1902: An Exhibition of Paintings and Pastels*, 3–24 February 1968.
1968 Hirschl & Adler	Hirschl & Adler Galleries, New York, *The American Impressionists*, 12–30 November 1968.
1970 Coe Kerr Gallery	Coe Kerr Gallery, Inc., New York, *150 Years of American Still-Life Painting*, 27 April–16 May 1970.
1971 Lowe Art Museum	Lowe Art Museum, University of Miami, Coral Gables, Florida, *French Impressionists Influence American Artists*, 19 March–25 April 1971.
1973 Metropolitan Museum	The Metropolitan Museum of Art, New York, *American Impressionist and Realist Paintings and Drawings from the Collection of Mr. and Mrs. Raymond J. Horowitz*, 19 April–3 June 1973.
1973 National Gallery	National Gallery of Art, Washington, D.C., *American Impressionist Painting*, 1 July–26 August 1973; Whitney Museum of American Art, New York 18 September–2 November; Cincinnati Art Museum, 15 December–31 January 1974; North Carolina Museum of Art, Raleigh, 8 March–29 April.

1975 New Orleans Museum	New Orleans Museum of Art, *A Panorama of American Painting: The John J. Mc Donough Collection*, 18 April–8 June 1975; Fine Arts Gallery of San Diego, 30 June–10 August; Marion Koogler McNay Art Institute, San Antonio, 12 September–19 October; Arkansas Arts Center, Little Rock, 14 November–28 December; The Westmoreland County Museum of Art, Greensburg, Pennsylvania, 26 January–8 March 1976; North Carolina Museum of Art, Raleigh, 6 April–1 June; Oklahoma Art Center, Oklahoma City, 1 July–15 August; The Butler Institute of American Art, Youngstown, Ohio, 3–31 October.
1975 Mint Museum	Mint Museum of Art, Charlotte, North Carolina, *American Paintings from the Collection of the North Carolina Museum of Art*, 7 September–19 October 1975.
1977 Whitney Museum	Whitney Museum of American Art, New York, *Turn-of-the-Century America: Paintings, Graphics, Photographs, 1890-1910*, 30 June–2 October 1977; St. Louis Art Museum, 1 December–12 January 1978; Seattle Art Museum, 2 February–12 March; The Oakland Museum, 4 April–28 May.
1980 Henry Art Gallery	Henry Art Gallery, University of Washington, Seattle, *American Impressionism*, 3 January–2 March 1980; Frederick S. Wight Gallery, University of California at Los Angeles, 9 March–4 May; Terra Museum of American Art, Evanston, Illinois, 16 May–22 June; Institute of Contemporary Art, Boston, 1 July–31 August.
1980 William Benton Museum	William Benton Museum of Art, University of Connecticut, Storrs, *Connecticut and American Impressionism*, 17 March–30 May 1980; Hurlbutt Gallery, Greenwich Library, Connecticut, 20 March–31 May; Lyme Historical Society, Old Lyme, Connecticut, 21 March–21 June.
1983 Montclair Art Museum	Montclair Art Museum, New Jersey, *Down Garden Paths: The Floral Environment in American Art*, 1 October–30 November 1983; Terra Museum of American Art, Evanston, Illinois, 13 December–12 February 1984; Henry Art Gallery, University of Washington, Seattle, 1 March–27 May.
1984 Whitney Museum	Whitney Museum of American Art, New York, *Reflections of Nature: Flowers in American Art*, 1 March–20 May 1984.
1985 Rollins College	George D. and Harriet W. Cornell Fine Arts Center, Rollins College, Winter Park, Florida, *The Genteel Tradition: Impressionist and Realist Art from the Ira and Nancy Koger Collection in Celebration of the Centennial of Rollins College*, 1 November 1985–26 January 1986.
1985 North Carolina Museum	North Carolina Museum of Art, Raleigh, *An American Perspective*, 14 December 1985–26 January 1986.
1987 Hirschl & Adler	Hirschl & Adler Galleries, Inc., New York, *Painters in Pastel: A Survey of American Works*, 25 April–5 June 1987.
1988 Fairfield University	Center for Financial Studies, Fairfield University, Connecticut, *American Art, Past and Present: A Selection of Important Artworks from the Kennedy Galleries*, 6 November 1988–11 January 1989.

REFERENCES

Albright Academy Notes 1913 — "Memorial Exhibition of the Works of John H. Twachtman." *Albright Academy Notes* (Buffalo) 8 (April 1913): 65–67.

Anderson 1980 — Anderson, Dennis R. *American Flower Painting.* New York: Watson-Guptill, 1980.

Art Amateur 1898 — "The National Academy of Design." *Art Amateur* 38 (May 1898): 131–132.

Art Bulletin [1907] — "John Twachtman." *Art Bulletin* 6 (5 January [1907]): 1 [incorrectly dated 1906].

Baur 1936 — Baur, John I. H. "Modern American Painting." *Brooklyn Museum Quarterly* 23 (January 1936): 3–19.

Boston Evening Transcript 1898 — "The Fine Arts: Exhibition by Ten American Painters at the St. Botolph Club." *Boston Evening Transcript*, 27 April 1898, p. 16.

Boyle 1974 — Boyle, Richard J. *American Impressionism.* Boston: New York Graphic Society, 1974.

Boyle 1979 — Boyle, Richard J. *John Twachtman.* New York: Watson-Guptill, 1979.

Brooklyn Museum 1979 — *The Brooklyn Museum: American Paintings.* Introduction by Linda S. Ferber. Brooklyn: Brooklyn Museum, 1979.

Clark 1924 — Clark, Eliot. *John Twachtman.* New York: Privately Printed, 1924.

de Kay 1918 — de Kay, Charles. "John H. Twachtman." *Arts and Decoration* 9 (June 1918): 73–76, 112, 114.

Forgey 1973 — Forgey, Benjamin. "American Impressionism: From the Vital to the Academic." *Art News* 72 (October 1973): 24–27.

Foshay 1984 — Foshay, Ella M. *Reflections of Nature: Flowers in American Art.* Exh. cat. New York: Whitney Museum of American Art, 1984.

Gerdts 1980 — Gerdts, William H. *American Impressionism.* Exh. cat. Seattle: Henry Art Gallery, University of Washington, 1980.

Gerdts 1981 — Gerdts, William H. *Painters of the Humble Truth: Masterpieces of American Still Life, 1801–1939.* Columbia: University of Missouri Press, 1981.

Gerdts 1983 — Gerdts, William H. *Down Garden Paths: The Floral Environment in American Art.* Exh. cat. Rutherford, N.J.: Fairleigh Dickinson University Press [for the Montclair Art Museum, Montclair, N.J.], 1983.

Gerdts 1984 — Gerdts, William H. *American Impressionism.* New York: Abbeville Press, 1984.

Gerdts and Burke 1971 — Gerdts, William H. and Russell Burke. *American Still-Life Painting.* New York: Praeger, 1971.

Goodrich 1965 — Goodrich, Lloyd. "Rebirth of a National Collection." *Art in America* 53 (June 1965): 78–81.

Hale 1957 — Hale, John Douglass. *The Life and Creative Development of John H. Twachtman.* 2 vols. Ph.D. dissertation, Ohio State University, Columbus, 1957. Ann Arbor: University Microfilms International, 1958.

Hall 1897

Hall, H. Eugene. "Some of the Striking Things at the Art Museum's Spring Exhibition." *Cincinnati Commercial Tribune*, 23 May 1897, p. 179.

International Studio 1898

"American Studio Talk." *International Studio* 4 (April 1898): xiv, supp.

Katzander 1981

Katzander, Howard L. "The Little Bargains in American Painting." *Architectural Digest* 38 (February 1981): 172, 176.

Lane 1942

Lane, James W. "Twachtman at his Best." *Art News* 41 (1–14 March 1942): 29.

National Museum of American Art 1983

National Museum of American Art, Smithsonian Institution, Washington, D.C. *Descriptive Catalogue of Painting and Sculpture in the National Museum of American Art*. Boston: G. K. Hall & Co., 1983.

New-York Daily Tribune 1903

"The Twachtman, Colman and Burritt Collections." *New-York Daily Tribune*, 21 March 1903, p. 9.

New York Mail and Express 1898

"Art Notes." *New York Mail and Express*, 30 March 1898, p. 7.

New York Sun 1898

"Art Notes: Exhibition by Ten American Painters at Durand-Ruel Gallery." *New York Sun*, 30 March 1898, p. 6.

New York Times 1898

"American Painters' Display." *New York Times*, 30 March 1898, p. 6.

New York Times 1901

"A Trio of Painters." *New York Times*, 7 March 1901, p. 8.

North Carolina Museum, *Bulletin* 1974

"Recent Acquisitions." Exh. cat. North Carolina Museum of Art, *Bulletin* 12 (March 1974): 12.

North Carolina Museum, *Bulletin* 1976

"Biennial Report July 1, 1973–June 30, 1975." North Carolina Museum of Art, *Bulletin* 13 (1976): 26.

North Carolina Museum 1983

The North Carolina Museum of Art: Introduction to the Collections. Edited by Edgar Peters Bowron. Chapel Hill: University of North Carolina Press for The North Carolina Museum of Art, Raleigh, 1983.

Philadelphia Daily Telegraph 1898

"Fine Display at the Art Club Exhibition." *Philadelphia Daily Evening Telegraph*, 12 November 1898, p. 6.

Philadelphia Inquirer 1898

"The Art Club's Winter Exhibition: Oil Painting and Sculpture in the Broad Street Gallery." *Philadelphia Inquirer*, 13 November 1898, p. 4.

Philadelphia Times 1898

"Art Club Exhibition." *Philadelphia Times*, 13 November 1898, p. 6.

Pilgrim 1978

Pilgrim, Dianne H. "The Revival of Pastels in Nineteenth Century America: The Society of Painters in Pastel." *American Art Journal* 10 (November 1978): 43–62.

Price 1972

Price, Vincent. *The Vincent Price Treasury of American Art*. Waukesha, Wisc.: Country Beautiful Corp., 1972.

Public Ledger–Philadelphia 1898 "Art Club's Annual Show." *Public Ledger–Philadelphia*, 14 November 1898, p. 3.

Smithsonian Institution 1933 Smithsonian Institution, National Gallery of Art. *Catalogue of American and European Paintings in the Gellatly Collection.* Washington, D.C.: Smithsonian Institution, National Collection of Fine Arts, 1933.

Smithsonian Institution 1954 Smithsonian Institution. National Collection of Fine Arts. *Catalogue of American and European Paintings in the Gellatly Collection.* 4th ed. Washington, D.C.: Smithsonian Institution, National Collection of Fine Arts, 1954.

Stebbins 1976 Stebbins, Theodore E., Jr. *American Master Drawings and Watercolors.* New York: Harper and Row, 1976.

Tucker 1931 Tucker, Allen. *John H. Twachtman.* Exh. cat. New York: Whitney Museum of American Art, 1931.

Van Dyke 1898 V. D., J. C. [John Charles Van Dyke]. "Ten American Painters." *New York Evening Post*, 1 April 1898, p. 7.

Williams 1965 Williams, Mary Frances. *Catalogue of the Collection of American Art at Randolph-Macon Woman's College.* Charlottesville: University Press of Virginia, 1965.

Williams 1972–73 Williams, Mary F[rances]. "The Painting Collection at Randolph-Macon." *Art Journal* 32 (Winter 1972–73): 192–195.

Williams 1977 Williams, Mary Frances. *Catalogue of the Collection of American Art at Randolph-Macon Woman's College*, 2d ed. Charlottesville: University Press of Virginia, 1977.

Index to Reproductions

Photographs:
Bill Burt (Twachtman, *Apples and Grapes*), p. 26
Patricia Layman Bazelon (Twachtman, *Meadow
 Flowers, Meadow Flowers,* detail), pp. 44, 49, 57
Edward Owen (Twachtman, *Tiger Lilies*), p. 16
Sidney Glass (Twachtman, *The Cabbage Patch*),
 p. 63
Glenn Tucker (Twachtman, *Azaleas*), p. 67
Kennedy Galleries (Twachtman, *A Garden Path*),
 p. 69
Brian Schrum (*Weeds and Flowers, Irises*),
 pp. 87, 93

Design:
Marcus Ratliff Inc., New York
Typesetting:
Trufont Typographers, Inc., New York
Lithography:
Princeton Polychrome, New Jersey
Editor:
Sheila Schwartz
Bibliographic Editor:
Carol Lowrey